T0112991

**THE SOLEBAY
TAPESTRIES**

THREADS
OF HISTORY

het scheepvaart
national maritime
museum

THE
SOLEBAY
TAPESTRIES

THREADS
OF
HISTORY

North Sea

England

Solebay •

• Amsterda

Utrec

London
•

Chatham •

• Antwerp

The English Channel

France

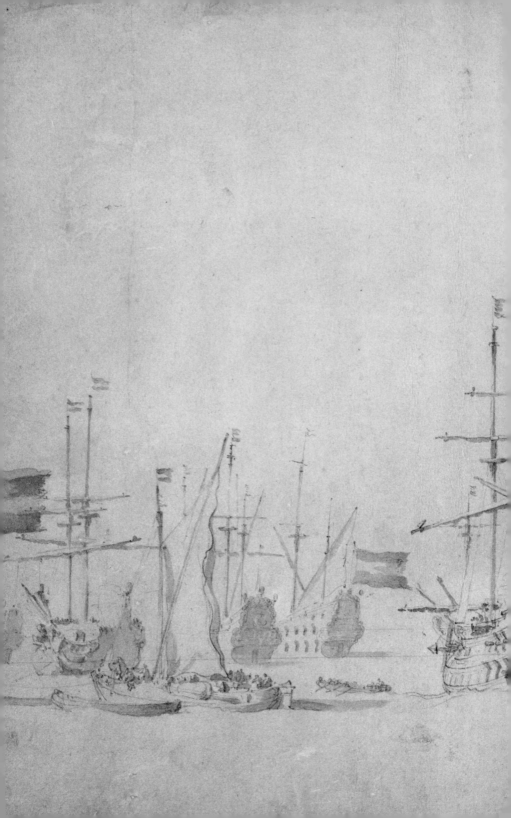

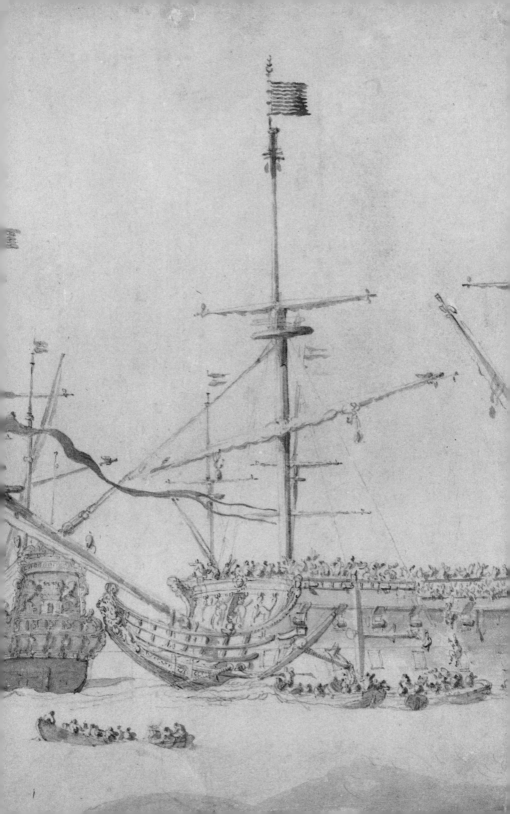

'At three of clock in the morning we heard guns of our scouts in the offing; so we immediately discovered the Dutch fleet coming upon us in the wind.'[1]

'By 4 clock in the morning the enemy's fleet appeared, we being in the Sole Bay, many of our ships riding near the shore, especially our fireships and small craft. Before we could come into a line the enemy fell on us.'[2]

◄
Sketch of the *Eendracht* during a council of war in the Vlie estuary, 1658 (detail).
See page 38

Battle of Solebay

Early in the morning of 7 June 1672,[3] a Dutch fleet commanded by Lieutenant Admiral Michiel de Ruyter (1607-1676) encountered a combined Anglo-French fleet at Sole Bay, an anchorage south of the English port of Southwold in Suffolk county on the east coast of England. The Dutch were outnumbered – 75 Dutch ships faced an Anglo-French force of 93 vessels – but the Dutch had the element of surprise. The ensuing battle signalled the start of the Third Anglo-Dutch War (1672-1674) in a year which is remembered as the Republic of the Seven United Provinces' disaster year (Rampjaar). French troops had already invaded the Netherlands, supported by the armies of the bishop of Munster and the Elector of Cologne. It seemed only a matter of time before the country would surrender and the Dutch republican experiment collapse. The purpose of De Ruyter's mission was to seek out enemy ships on the North Sea and prevent a simultaneous Anglo-French invasion of the Dutch coast.[4]

De Ruyter managed to surprise the allied fleet. The wind, at first working in the Dutch's favour, later lessened, and the allied fleet, commanded by James Stuart, Duke of York, the king's brother and heir to the throne (1633-1701), took advantage of the tide and used jolly boats to tow the ships in a line of battle. The subsequent fight was ferocious. With light wind, the heavy ships found manoeuvring difficult. This made the encounter all the fiercer, or as nineteenth-century historian Johannes de Jonge wrote, the ships 'didn't separate, but continued fighting for hours.' Eventually, a Dutch fireship managed to reach the *Royal James*, the flagship of the English blue squadron, and set it ablaze. Even by the end of the day, the battle remained victoryless. De Jonge concluded: 'As Lieutenant Admiral De Ruyter and most of the other officers of the country's navy later testified, this battle was the severest and longest naval encounter fought to date.' Despite the battle's intensity, no clear winner emerged. The English navy lost more men, but the Dutch fleet lost more ships. Nonetheless, a potential invasion of the Dutch coast had been averted, for now.[5]

Although the outcome was undecided, the battle was celebrated as a triumph by both sides of the North Sea. For the Dutch it was a tactical success and a respite from stress in a time of existential peril. The English also hailed the Battle of Solebay as a victory to be celebrated in appropriate fashion by the English court. And who better to illustrate this glorious English triumph than the famous marine painter Willem van de Velde the Elder (1611-1693), who had recently taken up residence as the official artist at the court of King Charles II?

A monumental acquisition

In 2020, the Scheepvaartmuseum, the National Maritime Museum of the Netherlands in Amsterdam, purchased two tapestries from a series of six wall hangings which depict the Battle of Solebay. The acquisition was a long time in the making. The works were presented by the Simon Franses Gallery of London at the annual TEFAF art fair in Maastricht in 2019, but raising the necessary funds to purchase took more than a year.

The tapestries are in many ways the museum's biggest acquisition, both in their physical size and the funds needed to acquire. Museum acquisitions of this size are not possible without the help of external funding. In this case it was due to the support of Vereniging Rembrandt (especially its Rembrandt UK Circle Fund), the Nationaal Aankoopfonds of the Dutch Ministry of Education, Culture and Science, Mondriaan Fonds, Vereeniging Nederlandsch Historisch Scheepvaart Museum, BankGiro Loterij, Samenwerkende Maritieme Fondsen and Het Compagnie Fonds.

The Solebay Tapestries, as they are now called by the museum, mark an interesting turning point in the life and career of the marine artist Willem van de Velde the Elder. His designs for them were among the very first commissioned after he moved from Amsterdam to London. They are also a major addition to the Scheepvaartmuseum's already substantial collection of works by father and son Van de Velde. While the previously acquired works tend to portray the various naval encounters of maritime history from mainly a Dutch perspective, these tapestries provide a rather unique English view of the Battle of Solebay within the Dutch-oriented narrative of the museum. This is a perspective which has, until recently, largely been overlooked in the collection.

In this publication we will survey the present state of knowledge regarding the tapestries and look at possible directions that researchers may choose to continue.

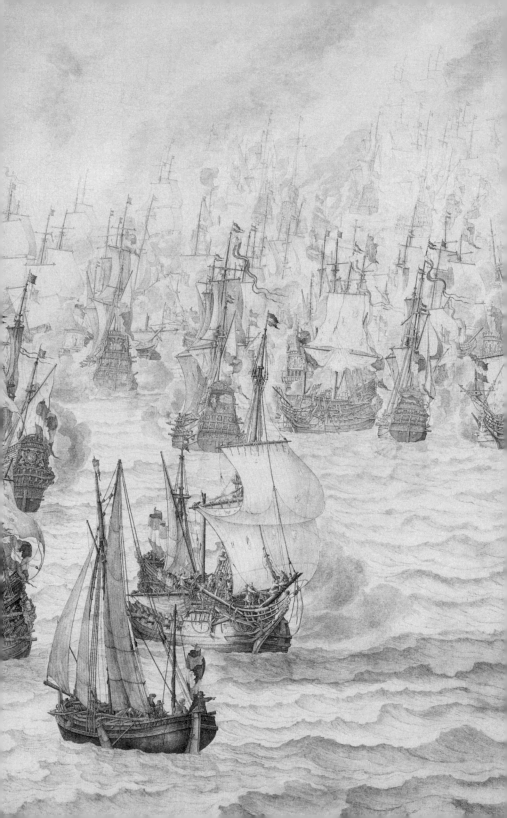

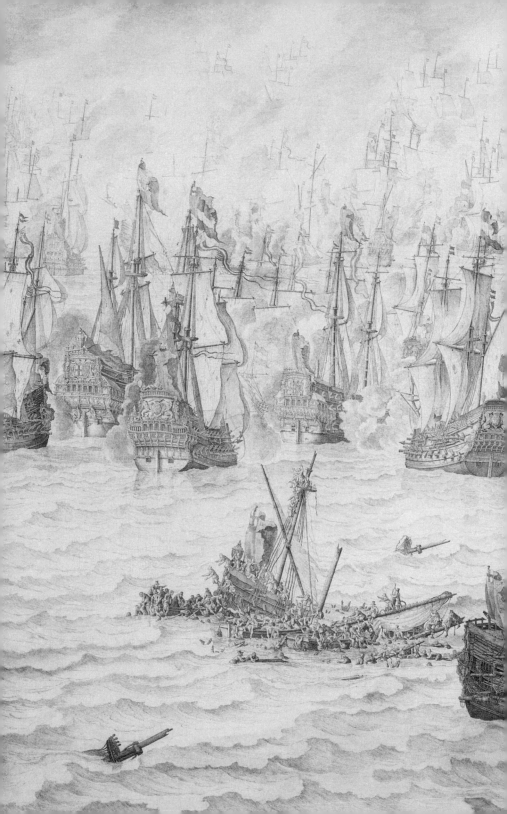

'The pride of the enemy would now be a little dented and the present bloody war would now end in a fair and secure peace.'

A new enemy: the Anglo-Dutch wars of the seventeenth century

In the second half of the seventeenth century, the Republic of the Seven United Provinces faced a new enemy: England. This came as quite a surprise at the time as the two countries had much in common. Both countries were predominantly Protestant. Both had turned their back on an absolute monarchy in favour of a republican form of government. Except for the merchant republic of Venice and the federation of mountain states of Switzerland, republics were a bit of an oddity in a Europe full of monarchies. The Dutch Republic had reached a period of so-called 'true liberty' (*ware vrijheid*) by peaceful means after the death of prince Willem II of Orange in 1650. Meanwhile, Johan de Witt (1625-1672) as the Grand Pensionary of Holland (the most prominent of Dutch states) had effectively governed the country since 1652. The English Civil War, however, culminated in the violent removal and unprecedented execution of its king, Charles I (1600-1649). Oliver Cromwell (1599-1658) stepped up in his place and was appointed Lord Protector of the English Commonwealth. Meanwhile, the claimant to the English throne, Charles Stuart (1630-1685), fled the country after a disastrous military campaign and found refuge in France and later in the Dutch Republic. The crowned heads of Europe looked on in suspicion and dread as the two countries on either side of the North Sea overturned in what, in their eyes, was the natural order of things and thrived as republics. While all of this might have led to a sense of common purpose, conflict soon prevailed. Commercial and monetary interests proved a more divisive force than shared political or religious beliefs could unite.

As the Dutch provinces fought off their Spanish overlords during the Dutch Revolt which lasted for eighty years, their commercial fleet expanded and by the 1640s the Republic had become the leading force in the European economy. The Dutch supremacy at sea left the English standing in the cold. Since the Middle Ages, England had earned a steady and healthy income from exporting

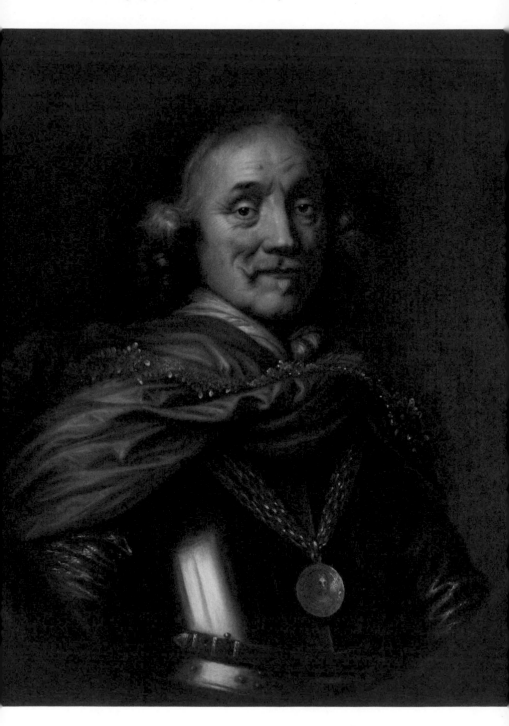

wool to the European mainland. An English wool trader explained the situation in 1650: 'Whereas we formerly brought home foure or five thousand baggs of cloth wooll and the Hollanders scarce a thousand [...], they now carry away five or six thousand and wee bring not past 12 or 1500 in the yeare at most.' Many English towns prospered from the wool trade, but the English aristocracy land-owners benefited the most. Unsurprisingly, they asked the English Parliament which responded in 1651 by passing the Navigation Act. This set of protective measures ensured that English vessels carried more products destined for the English market and that English exports were carried as much as possible by English ships. This system was deliberately designed to protect the domestic economy against foreign competition and is better known as mercantilism. Inspired by the English example, throughout Europe countries imposed similar regulations as the seventeenth century continued. It put Dutch merchants at a disadvantage as they had flourished on the previous free trade system. The economic consequences were considerable for the Dutch Republic. It is unsurprising then that the Dutch applied diplomatic pressure to have the Navigation Act repealed.[6]

Another issue was the so-called freedom of the seas. The English Crown had long claimed sovereignty over the waters surrounding the British Isles. For Dutch ships sailing the Channel and the North Sea this meant paying English ships homage by lowering their flag as a sign of respect. Moreover, England claimed the right within its home waters to stop and search foreign ships for smuggled contraband. This was in direct opposition to the Dutch principles of free trade and freedom of the seas, laid down by the Dutch lawyer Hugo Grotius (Hugo de Groot, 1583-1645) in his book *Mare Liberum* (1609).

◄
Jan Lievens (1607-1674), Portrait of Maarten Harpertszoon Tromp (1598-1653), c. 1653.
A.1685

►
Willem van de Velde the Elder (1611-1693), The Battle of the Gabbard on 12 and 13 June 1653, 1654.
1990.0949

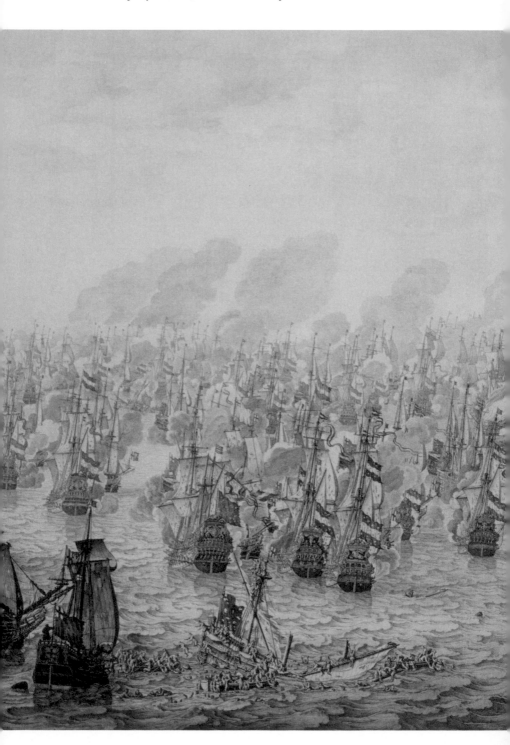

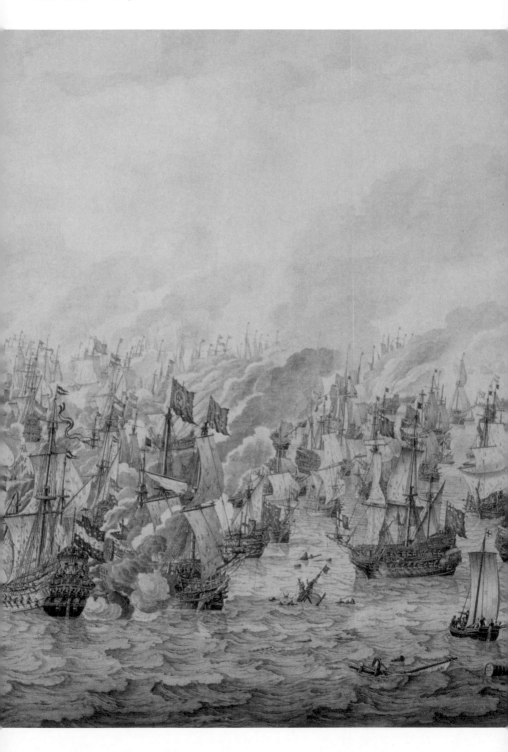

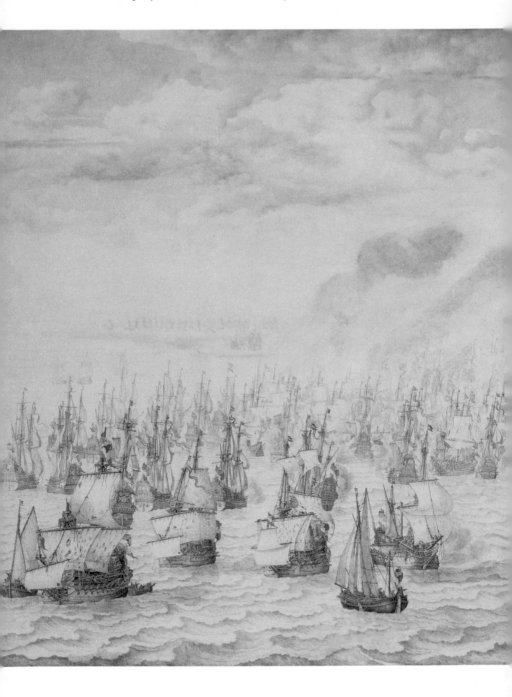

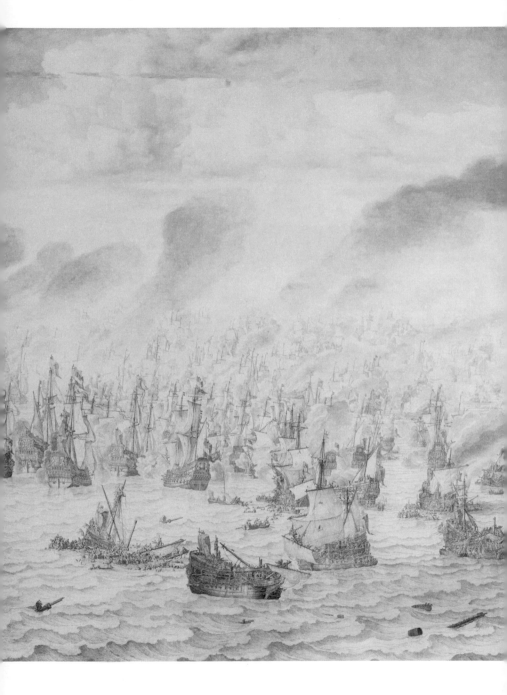

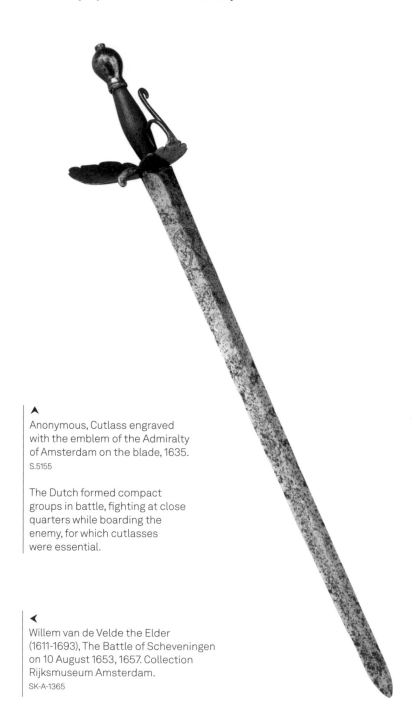

∧
Anonymous, Cutlass engraved
with the emblem of the Admiralty
of Amsterdam on the blade, 1635.
S.5155

The Dutch formed compact
groups in battle, fighting at close
quarters while boarding the
enemy, for which cutlasses
were essential.

◄
Willem van de Velde the Elder
(1611-1693), The Battle of Scheveningen
on 10 August 1653, 1657. Collection
Rijksmuseum Amsterdam.
SK-A-1365

Tensions grew in late May 1652, when a Dutch fleet commanded by Lieutenant Admiral Maarten Tromp (1598-1653) failed to strike their colours in salute. The slighted English fleet responded by opening fire on the Dutch squadron. An encounter followed off the coast of Dover on 31 May. It was the opening shot in a series of no less than three Anglo-Dutch wars.[7]

After the skirmish at Dover, Dutch and English fleets of warships clashed several times during the First Anglo-Dutch War (1652-1654) and their encounters took place most often on the North Sea. Having failed to maintain a sizeable navy after the 1648 Treaty of Westphalia (also known as the Peace of Münster, after the German town where the negotiations took place), the Dutch resorted to hiring and refitting armed merchantmen. At first, Dutch naval strategy was largely defensive, focusing on protecting commercial convoys. A major engagement took place on 8 October 1652 at the Kentish Knock (*Slag bij de Hoofden*), which the English won. The battle off Dungeness (*Zeeslag bij de Singels*) on 10 December 1652 was a strategic victory for Maarten Tromp. The Battle of Portland (*Driedaagse Zeeslag*) in the English Channel was the first clash of 1653. While Tromp's fleet was beaten and the Channel remained closed to Dutch shipping for the rest of the war, he nonetheless managed to escort half the merchantmen under his protection to safety. Tromp was still employing the traditional melee tactic of splitting his main force into compact fighting groups, firing on and boarding the enemy in unison. Meanwhile, General at Sea Robert Blake (1598-1657) appeared to have adopted and improved a novel tactic of forming a line, something which Tromp had previously tried while fighting the Spanish at the Battle of the Downs (*Slag bij Duins*) in 1639. At the Battle of the Gabbard (*Slag bij Nieuwpoort*) the Dutch fleet was beaten by the English sailing in a line of battle under the command of General at Sea George Monck (1608-1670) and General at Sea Richard Deane (1610-1653). Tromp tried to break through an English blockade of the Dutch coast at the Battle of Scheveningen (*Slag bij Ter Heijde*) on 10 August 1653 and it was there that he was fatally wounded by a shot from an English sharpshooter.[8]

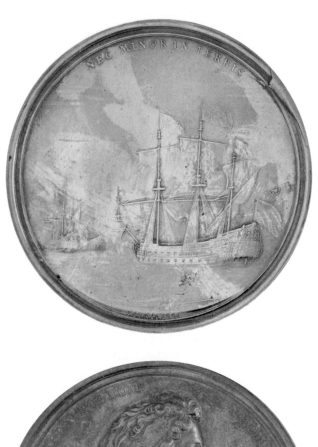

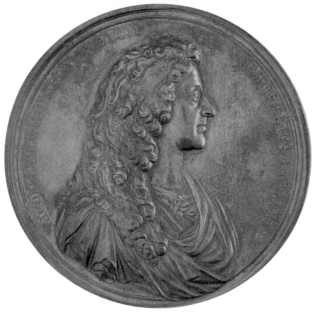

By then, both countries were struggling to continue the war. Although the English had won most of the battles on the North Sea, they failed to deliver a decisive blow. Historian Jonathan Israel argues that by keeping the English warships busy on the North Sea, the Dutch navy prevented them from dominating Dutch shipping elsewhere. As a result, Israel maintains, that in the end English trade suffered more during the war than Dutch. In 1654, the exhausted combatants agreed to peace. England was the moral victor: the Navigation Act remained in force. The English also made various draconian demands during the negotiations. Most importantly, England and the Republic – where Johan de Witt now firmly controlled – had secretly agreed that no scion of the House of Orange should ever hold the office of stadholder, known as the Act of Seclusion.[9] Meanwhile, their losses in the recent war had shown the Dutch that they needed purpose-built warships for a standing navy. In early 1653, an ambitious programme was launched to build a naval fleet, with about sixty warships built. These ships were ready in the summer of 1654.[10]

A little over a decade later, during the Second Anglo-Dutch War (1665-1667), Michiel de Ruyter (1607-1676) proved himself as one of the greatest admirals in Dutch maritime history. Tension between England and the Dutch Republic had been growing again in the 1660s as the causes of the first war remained unresolved. The damage to the Dutch merchant fleet had been largely material and as such was repairable and the Dutch merchant ships remained the biggest merchant fleet in Europe. Meanwhile, Dutch influence expanded further, and the commercial rivalry remained a major concern. Not only was the Navigation Act still a difficult obstacle for the Dutch, but tensions were also spreading around the globe. In Africa and the Americas, the Dutch West India Company (WIC) competed vigorously with their English rivals to establish a foothold in the trans-Atlantic slave trade, while in Asia the influence of the

◄

Jean Roëttiers (1631-1703), Medal commemorating the English victory at Lowestoft on 13 June 1665, c. 1665.
A.0015(04)

Dutch East India Company (VOC) expanded at the cost of English commercial ventures. Although war officially started in 1665, the English capture of Dutch slave trading forts on the west coast of Africa in 1664 – and their subsequent recapture under the command of Michiel de Ruyter - were significant forewarnings. In effect, war had already started a year before it was officially declared. The main difference with the previous Anglo-Dutch war was that on the eve of the Second Anglo-Dutch war, the Dutch admiralties were prepared, due especially to the ambitious construction programme launched in the 1650s.[11]

Any sense of optimism though was soon dispelled during the first encounter at the Battle of Lowestoft on 13 June 1665, which proved a major humiliation for the Dutch navy. The Dutch commander, Admiral Jacob van Wassenaer Obdam (1610-1665), had little maritime experience and died when his ship exploded. At Lowestoft, the Dutch lost seventeen ships and 6,000 men. The Four Days'

Battle from the 11 to 14 June 1666 remained undecided, with both sides claiming victory. At the Two Days' Battle, which began on 4 August 1666, the Dutch fleet was defeated. Moreover, De Ruyter and Cornelis Tromp (1629-1691) fell out with each other. England's Vice Admiral Robert Holmes (c. 1622-1692) attacked a merchant fleet at anchor off the islands of Vlieland and Terschelling on 19 and 20 August and hundreds of ships and their precious cargoes were lost at what became known as Holmes's Bonfire.

On both sides of the North Sea, pressure to end the financially crippling war soon began. Peace talks were held at the Dutch town of Breda, but after two fruitless months, Johan de Witt decided to look for a spectacular naval success to strengthen the Republic's negotiating position. He had toyed with the idea of attacking the English fleet at its naval base at Chatham near London before and in the summer of 1667, much of England's battle fleet was at anchor, precisely there. He sent his brother Cornelis (1623-1672) to represent him during this surprise attack on the unexpecting English fleet.[12]

For the Dutch navy, the raid was a resounding success. The Dutch attacked both the forts guarding the entrance to the River Medway and also the naval base where they scuttled or set fire to numerous vessels. The biggest prize of all was the *Royal Charles*, the English flagship. This was the ship Charles II returned to London from the Republic in 1660, when it was the *Naseby*. It was renamed *Royal Charles* when he was crowned king. It was this ship that the Dutch took back to the Republic as their prize. This was the success Johan de Witt needed as leverage at the negotiation table. Johan wrote to Cornelis regarding the raid, that he hoped: 'the pride of the enemy would now be a little dented and the present bloody war would now end in a fair and secure peace.' And so it was. In July 1667, without further stalling by the English dragging their feet, the Treaty of Breda was hastily signed.[13]

◄

Anonymous, Stern decoration from
the English flagship *Royal Charles*,
c. 1663-1664. Collection Rijksmuseum
Amsterdam.
NG-MC-239

The humiliation of a European king

After the Second Anglo-Dutch War, and especially the brazen attack on the naval base of Chatham and the capture of his flagship while peace negotiations were already taking place, the brand-new English King Charles II felt utterly humiliated. And it had become very personal. Charles had ascended the English throne in 1660 and thus restored the monarchy, but this came at a price. He had fled the country twice and spent several periods in exile. Before becoming king, he stayed in the Dutch Republic. There, he had taken to the water and become a keen sailor of Dutch yachts. As king, he introduced his new pastime to England.[14]

At the peace negotiations, it was the Dutch who were able to press their advantage and were awarded Suriname as well as Pulo Run, a strategically significant island in the Banda Sea in the Indonesian archipelago. Against this, the Republic lost the colony of New Netherlands, with its trading post of New Amsterdam (subsequently renamed to New York). It had proved difficult to hold the Dutch settlement since it was surrounded by English colonies. Moreover, the lucrative trade in beaver pelts had already declined to a point that it was no longer viable. The loss seemed marginal at the time. Yet, the principal gain for the Dutch was perhaps the relaxation of England's mercantile laws which had constrained Dutch shipping.

◀
Anonymous, Cannonball, excavated near the River Medway and traditionally said to have been fired by a Dutch ship during the raid on Chatham in June 1667.
S.7007(01)

▶
Jeronymus van Diest (II) (baptised 1631 – 1677/1697), The seizure of the *Royal Charles* during the raid on Chatham, 1667. Collection Rijksmuseum Amsterdam.
SK-A-1389

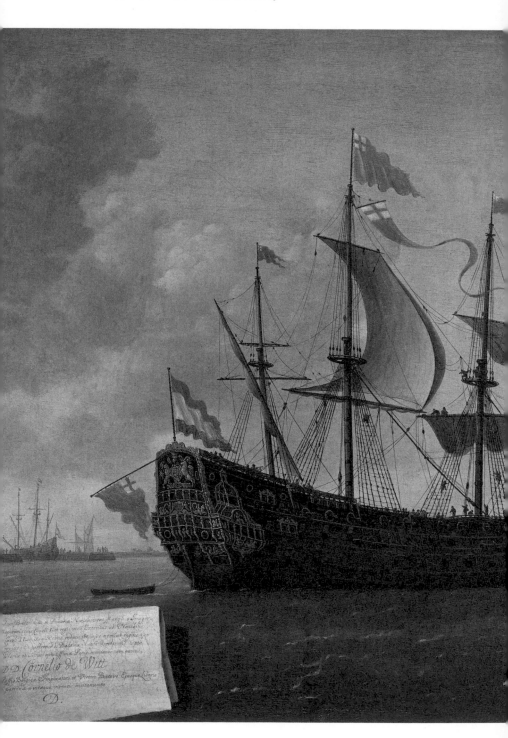

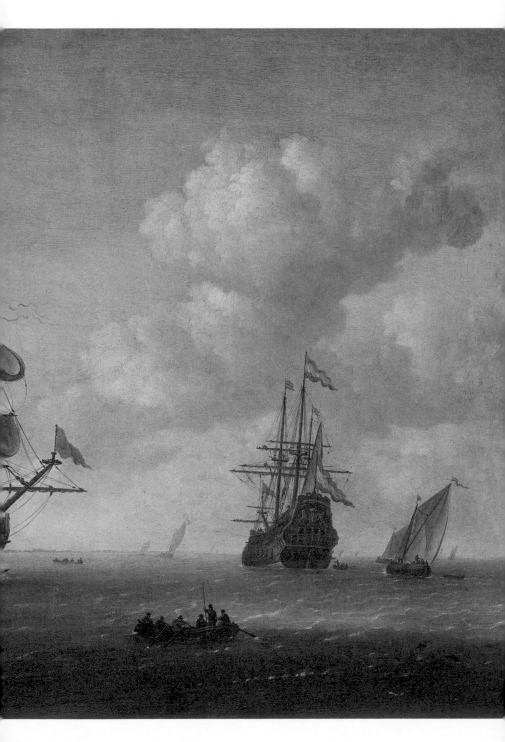

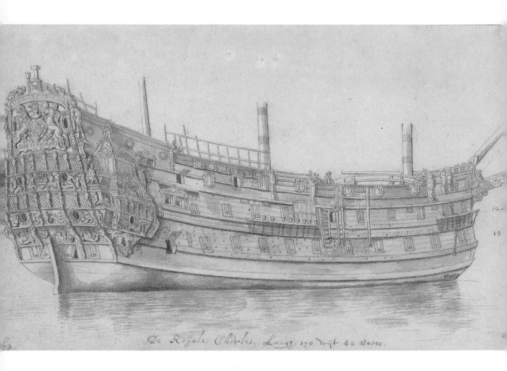

∧

Abraham Storck (baptised 1644-1708), Sketch of the *Royal Charles* at Hellevoetsluis port, 1672. Collection Rijksmuseum Amsterdam.
RP-T-00-256

➤

Cristoffel Adolphi (1632/1633-1684) and Jan Zoet (1609-1674), Medal marking the Treaty of Breda and the raid on Chatham, *c.* 1667.
A.0015(05).

A personified Dutch Republic tramples figures representing hate and malice underfoot, but unquestionably picturing the King of England.

Given the inherent bias of the peace, it is hardly surprising that rela-
tions between England and the Republic soon began to deteriorate.
The English king in particular had reason to be personally affronted
and vengeful. Johan de Witt was not blind to the king's situation
and summarised the monarch's grievance in a letter to a prominent
Dutch diplomat Coenraad van Beuningen (1622-1693). These affronts
could all be traced back to the Second Anglo-Dutch War.[15] If taking
his ship as a prize was not enough, there was also the particular
'aenstootelijckheid' or affront of the Mala Bestia medal.

To mark the signing of the Treaty of Breda – and indirectly the
successful raid on the River Medway – the province of Holland
commissioned poet Jan Zoet (1609-1674) and the famous medallist
Cristoffel Adolphi (1632/1633-1684), both inhabitants of Amsterdam,
to design a medal commemorating the peace. Together they came
up with a medal featuring a symbolic representation of the Breda
peace agreement on one side. On the reverse was a personification
of the Netherlands dressed in full armour, with burning ships in the
background (clearly referring to the Medway raid). The Netherlands
was shown trampling the personifications of hate and malice, whose
face was unmistakably modelled on portraits of Charles II. A motto
in Latin inscribed below stated *procul hinc mala bestia* (Away from
here, wicked beast!) For Charles, it was yet another blatant provoca-
tion from the boisterous Dutch.[16]

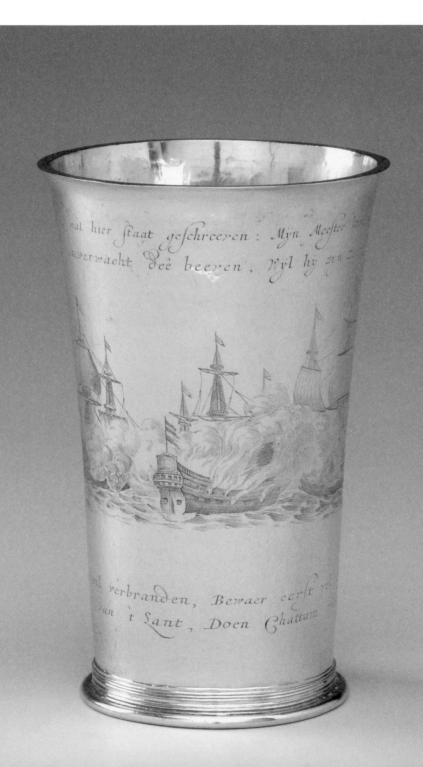

It did not stop there as the case of the captured *Royal Charles* remained another festering wound. Since its arrival in 1667, the ship had deteriorated in the port of Hellevoetsluis. Normally, a captured vessel would have been added to the fleet of the victor; however, the draught of this large ship was too deep for the shallow Dutch waters, especially when loaded with its heavy armament of more than 90 guns. Without purpose, the ship became a souvenir and a memory of the bold Medway raid. At one point, a rumour reached Charles II that his flagship had become a common tavern and was being run as a tourist attraction.[17] To add insult to injury, the ferry from England docked at the Hellevoetsluis and so the first thing every English traveller saw coming ashore in the Republic was the pride of the Royal Navy at anchor in a Dutch port.

Confronted with the diplomatic outrage it caused, the province of Holland attempted to recall the Mala Bestia medal and obtained the remaining copies from the medallist Adolphi. The Admiralty of the Meuse also tried to appease the English by offering the hulk of the *Royal Charles* for sale to timber merchants. The ship was bought in February 1672 and disassembled, but not before the stern decoration identifying the *Royal Charles* (today it is part of the Rijksmuseum collection) was removed and kept as a memento. The *Royal Charles*'s bowsprit was later fitted onto the *Zeven Provinciën*, Michiel de Ruyter's own flagship.[18]

◀

Marten van Wolfswinkel (1603-1684) and Dirck Claessen (?-?), Silver cup celebrating the raid on Chatham, 1668.
1990.0939.

The cup's inscription makes the point eloquently, translated from Dutch it reads: If you want to burn our merchant ships, make sure to defend your own beaches first.

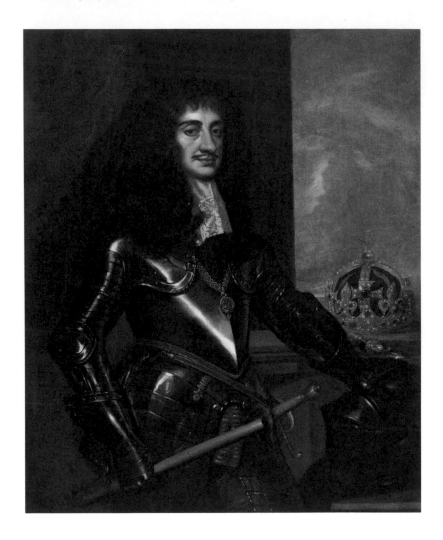

Peter Lely (1618-1680), Portrait
of King Charles II, *c.* 1670. Royal
Collection Trust / © His Majesty
King Charles III 2023.
RCIN 401223

Historian J.R. Jones argued that Johan de Witt used the raid on the Medway to bring about the end of the Second Anglo-Dutch War and improve the Republic's bargaining position at the peace talks. Although he succeeded in this, as Jones noted, De Witt made a major miscalculation: the humiliation at Chatham and a treaty without any benefits for England sent the Charles II into the arms of France where, together, they would conspire to take down the Dutch Republic. Louis XIV, aiming to expand French influence in the Low Countries, planned a covert alliance with England and in December 1670, France and England signed a secret treaty in Dover. Their common purpose was clear, to defeat the Dutch Republic and render it harmless and if possible, to destroy it. The victors would then share the spoils.[19]

➤
above:
Willem van de Velde the Elder (1611-1693), Sketch of the *Eendracht* during a council of war in the Vlie estuary, 1658.
A.1115(01)

➤
below:
Willem van de Velde the Elder (1611-1693), 'Journal' showing the English fleet on the Thames after the second Battle of Schooneveld, 1673.
A.3593(14)

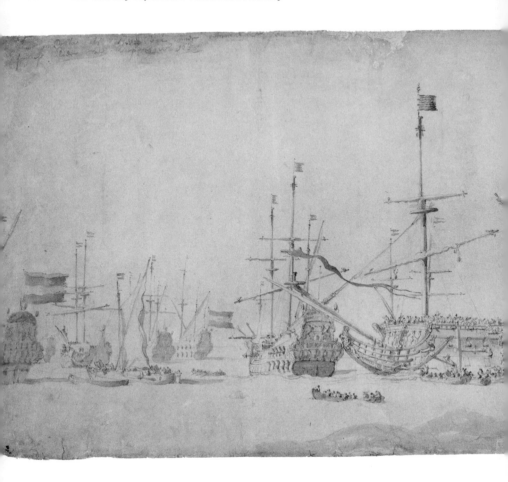

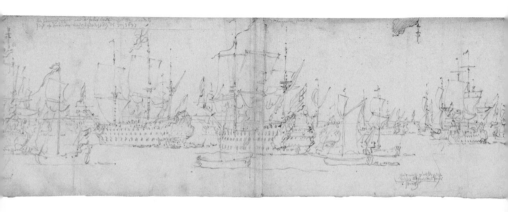

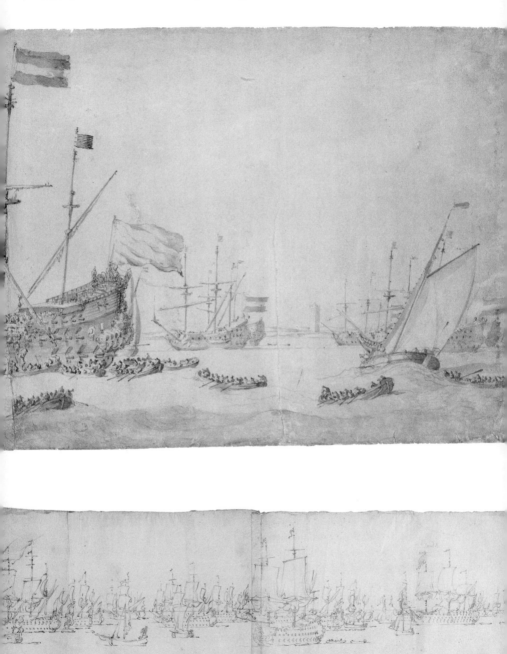

Workshop of the Willem van de Veldes: chroniclers of war

Amid the carnage of the Anglo-Dutch wars, the career of marine artist Willem van de Velde the Elder (1611-1693) advanced steadily. Little is known about Van de Velde's early years as a draughtsman, however, the few surviving public records indicate that his family were Flemish skippers who moved to Leiden. He married Judick van Leeuwen in 1631 and two years later, their son Willem (1633-1707) was born. In the 1630s the young family moved from Leiden to Amsterdam, probably for Willem to try his luck in the city's art market. His son Willem, as was common at the time, followed in his father's footsteps and later became the famous marine artist Willem van de Velde the Younger. Another son, Adriaen van de Velde (1636-1672), also joined the family art business. Adriaen, who mainly painted landscapes, died in 1672 at a relatively young age. There is a theory that their daughters also painted, or helped in the family workshop, although the proof is vague, and no evidence exists of their output.[20]

Willem van de Velde carved a niche for himself in the specialised Dutch art market with his pen paintings. These were drawings on panels or canvas in which he depicted naval battles and ships with extraordinary accuracy. It is clear that he drew with pen and ink, yet the type of ink and the way he prepared his surface is still the subject of ongoing research. With his keen eye for business, Van de Velde advertised the unique qualities of his paintings. The works were weatherproof, and they could even be displayed outdoors and easily cleaned with a wet sponge.[21]

Van de Velde the Elder made the detail in his pen paintings his true specialisation. To ensure his depiction of naval battles would be accurate, he sailed with the Dutch fleet on at least six occasions. He was present at Lowestoft in 1665, for example, and at the Four Days' Battle in 1666. The Admiralty of Amsterdam provided Van de Velde with a galliot and a crew for him to sketch and draw on during naval actions. He would also have received commissions as naval

draughtsman directly from the admiralty. When he sailed in his galliot he kept a pictorial journal, gluing sheets of paper together into long scrolls and recording the events of the battle to work on later in his studio.[22]

In the winter of 1672-1673, Willem van de Velde the Elder moved with his eponymous son to London, where they took up residence at the English royal court. What caused their migration is difficult to discern. Naturally, the financial crisis that followed the events which made 1672 a year of disasters would have played a major role. Additionally, because of the outbreak of war, the Dutch art market collapsed and also affected the Van de Veldes. Former Scheepvaartmuseum curator Remmelt Daalder, in his monograph on the Van de Velde workshop, points to various letters which show that Willem van de Velde the Elder was forced to lower his prices due to the miserable situation in the Republic. Both father and son seem also to have been in touch with the English king some time earlier, although it remains unclear whether the king had personally invited them to come and work for him in England. The English monarch issued pamphlets in the Dutch Republic during the Third Anglo-Dutch War encouraging Dutch residents to settle in England.[23] The Van de Veldes were hardly alone in emigrating across the North Sea as several Dutch artists also took up positions at the English court in this period.

>
Hendrick Danckerts (c. 1625 - 1680), View of Queen's House and Greenwich with London on the horizon, c. 1670, Collection National Maritime Museum Greenwich. BHC1818

Queen's House in Greenwich is on the left. This is where the Van de Veldes set up their workshop.

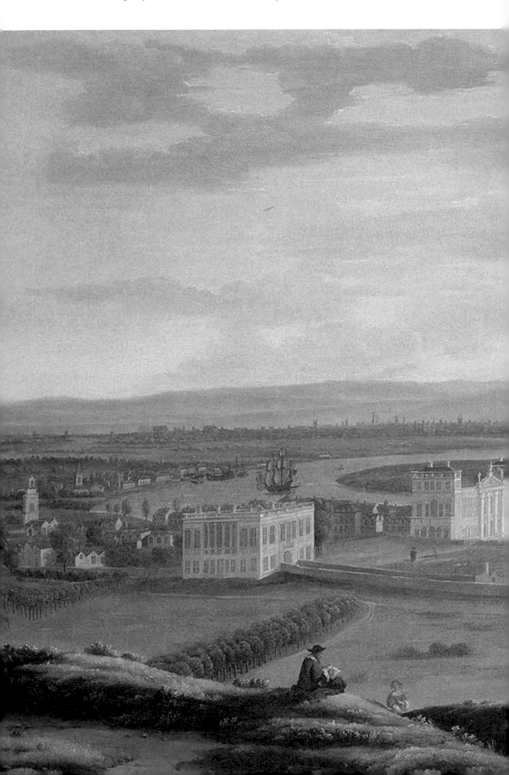

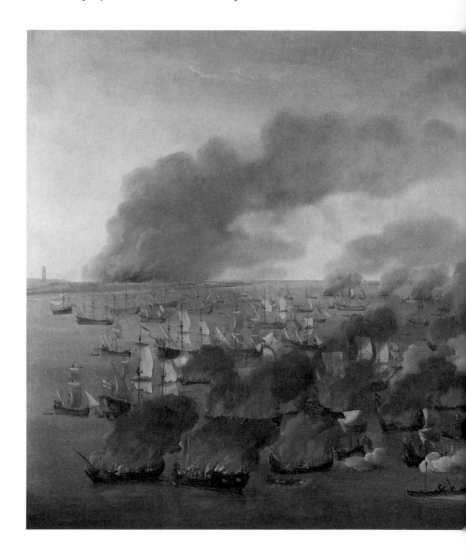

Having arrived in England, father and son entered the king's service.
They received an annual salary of a 100 pounds each and moved
into Queen's House, part of the royal palace of Greenwich. Today
it is home to the collection of paintings of the National Maritime
Museum. At first, the Van de Veldes were asked to paint scenes from
English maritime history, mostly battles with the Dutch from the
previous wars. An intriguing change in perspective now took place

◀

Willem van de Velde the Younger (1633-1707), Holmes's Bonfire, c. 1672-1688. Royal Collection Trust / © His Majesty King Charles III 2023.
RCIN 406560

This is one of the first major works father and son Van de Velde painted for the English court. James, Duke of York, commissioned twelve paintings depicting key events in England's war against the Dutch Republic. Shown here is the burning of one hundred and seventy Dutch merchantmen anchored off the Dutch isles of Terschelling and Vlieland.

for both father and son. For the Duke of York (later King James II), for example, they depicted the devastating attack by the English fleet on the Dutch merchantmen assembled off Terschelling in September 1666 (Holmes's Bonfire) where hundreds of Dutch ships were destroyed.[24] There is little chance they would have painted this scene for the open art market in the Dutch Republic.

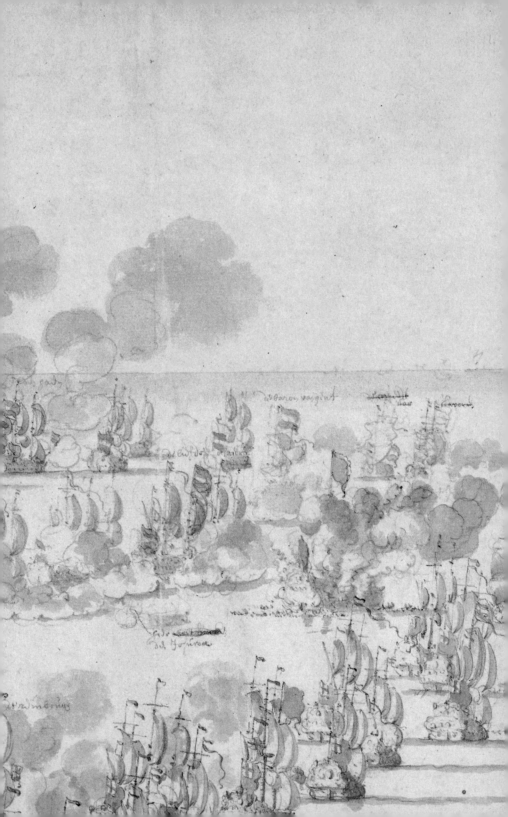

op hooghe arisont na Blommijs e oucea botwart e ort
bsquadm tot de lapijttds e dos help formats va hooght
is brisoto dag alos uijt de blickomigs nade elos gokoo

'They battered without
let or stay,
Until the evening of the day,
The Duke [of York] had beat
them tightly.

Of all the battles
gained at sea
This was the rarest victory
Since Philip's grand Armada'[34]

The Disaster Year

Conflict had been brewing for some time until in 1672, the Third
Anglo-Dutch War began. On 23 March, an English squadron attacked
a lightly armoured convoy of Dutch merchantmen returning from
Smyrna (Izmir). Most were cargo ships carrying produce from Tur-
key to the Dutch Republic. Although lightly armed, the Dutch did
not yield easily. Two of the English naval ships were unexpectedly
repelled and damaged, at which point the Dutch made their escape.
This skirmish marks the actual start of the Third Anglo-Dutch
War, although France and England only declared war on the Dutch
Republic two weeks later. Late in May, French troops invaded the
Republic, with the armies of the German bishops of Münster and
Cologne following. In a matter of weeks, a huge swath of territory

 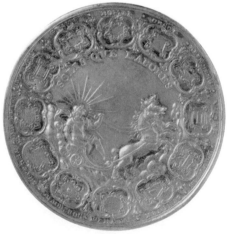

▲
Anonymous. Medal marking the French
conquest of twelve Dutch towns in
1672, struck in 1672. Collection
Rijksmuseum Amsterdam.
NG-VG-1-1062

The obverse shows King Louis XIV of
France, the reverse depicts him riding
a chariot surrounded by outlines of
the Dutch fortifications.

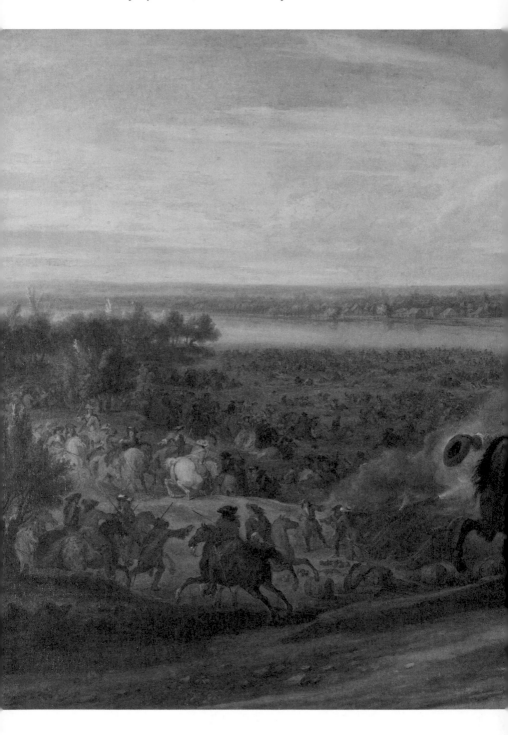

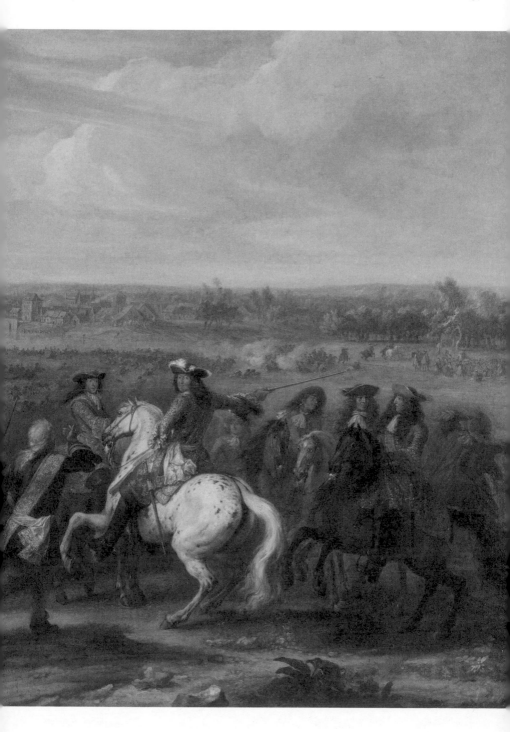

had fallen as the Republic suffered one defeat after another. By late June, the French had reached the province of Utrecht and it seemed only a question of time before the Republic would fall. The Dutch desperately looked for a sign of an end to these successive defeats. Might the navy achieve something? Now comparatively more ready for action than the army, the fleet was sent out to prevent an attack on the Dutch coast.

The Battle of Solebay on 7 June 1672, when the Dutch fleet fought against a combined Anglo-French fleet, was the first major confrontation of the Third Anglo-Dutch War (1672-1674). Given the precarious situation in which the Republic found itself, Johan de Witt instructed Michiel de Ruyter to attack the English ships before the French could join them. A repeat of the raid on the Medway of 1667 might achieve that objective. While De Ruyter planned precisely that with Cornelis and Johan de Witt, the latter emphasised that De Ruyter should act as seemed best in the circumstances. Arriving at the of the Medway, he discovered that the forts guarding the entrance along its banks had been reinforced. And while some ships were still docked at the river near Chatham, most of the English ships had already sailed. Michiel de Ruyter and Cornelis de Witt revised their plan.[25]

It was then that Michiel de Ruyter's fleet discovered the combined Anglo-French force further north along the east coast of England. It was moored in a coastal indentation south of the town of Southwold in Suffolk and known locally as the Sole Bay. The allied fleet was sheltering there because of a disease spreading among the crews. Recent storms had also damaged many ships 'and [we] were assured that [the enemy] had suffered considerable damage from the violent weather, because the galliot captains said they had seen

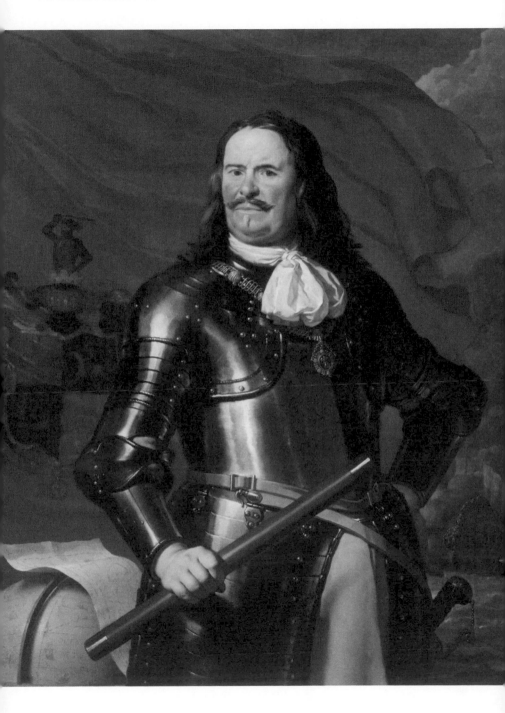

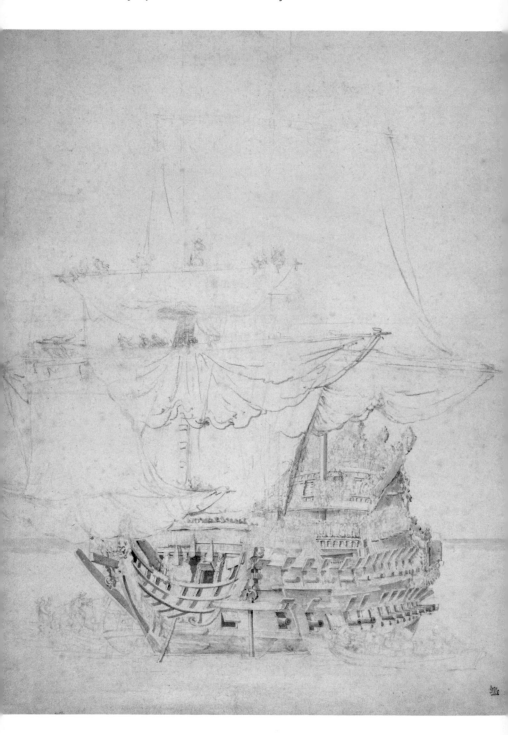

all kinds of debris from ships floating about.'[26] Historian Luc Pan-huysen argues that Cornelis de Witt and Michiel de Ruyter hoped to make the most of this situation by attacking immediately.[27] On 6 June, Michiel de Ruyter wrote about this in his ship's log stating 'We had resolved and decided before the afternoon of the 6th to search out the enemy at Sole Bay and to deliver battle.'[28]

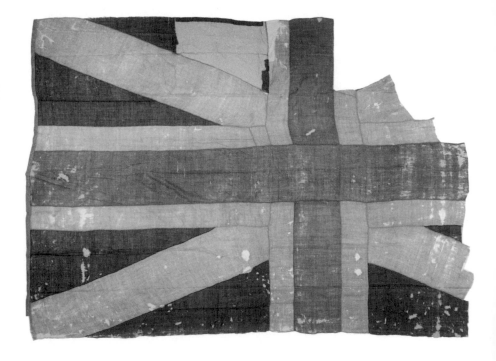

◀
Willem van de Velde the Elder (1611-1693), Sketch of the *Zeven Provinciën, c.* 1670.
A.0930

The ship was built for the Admiralty of the Meuse in 1665 and served as Michiel de Ruyter's flagship from 1666. De Ruyter sailed in the *Zeven Provinciën* at the Battle of Solebay.

▲
Anonymous, Fragment of a Union flag, allegedly captured by the Dutch at the Battle of Solebay. *c.* 1606-1672. Collection Rijksmuseum Amsterdam.
NG-MC-1889-83-10

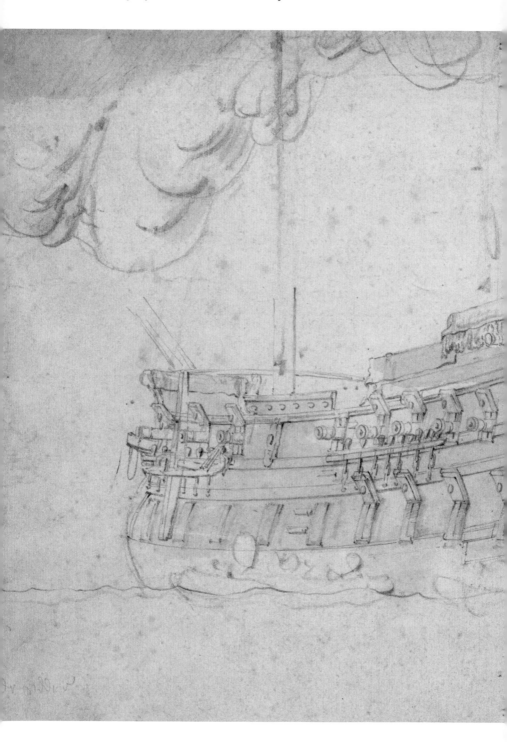

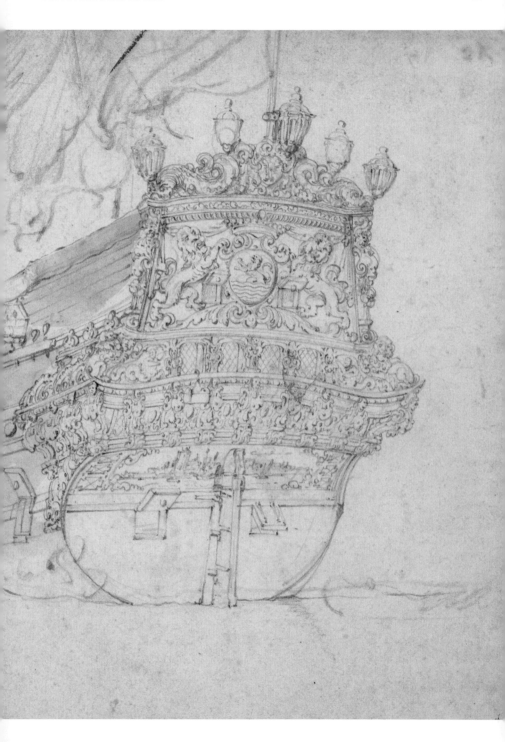

The battle did not produce a clear victor. While the Dutch lost more ships, the English lost more men. The battle had been extraordinarily fierce. Some days after the event, Cornelis de Witt wrote to his brother Johan de Witt that De Ruyter had confided in him that he had never experienced such a long, continuous fight before.[29] Cornelis included a brief report including his own impressions of the battle. Suffering from gout, he sat on a chair on deck at times and was unable to see his hand in front of his face 'because the incessant smoke was enough to prevent us seeing beyond our own ship;' so he had little to clarify about the course of the battle.[30]

All the three participants in the battle claimed victory. Even the French, whose thirty ships formed the white squadron of the combined fleet and became embroiled in a largely separate fight with a Dutch squadron commanded by Lieutenant Admiral Adriaen Banckert (1615/1620-1684), hailed themselves as the winners. Today, the Battle of Solebay is generally recognised as a tactical success for Michiel de Ruyter. The Dutch fleet managed to prevent a blockade of the Dutch coast and a potential invasion, since the severely damaged ships of both fleets were left to limp home for repairs. The Battle of Solebay was also the last major naval contest of that year.[31] Some of those who had fought were later deployed to help fend off the French inland, along the so-called Waterline for instance.[32]

◄
Willem van de Velde the Elder
(1611-1693), Sketch of the warship
Kampveere, c. 1660.
A.0149(0178)

►
Anonymous, published by
Marcus Willemsz. Doornick (active
1657-1703), Newssheet reporting
the Battle of Solebay, 1672.
Collection Rijkmuseum Amsterdam.
RP-P-OB-82.174

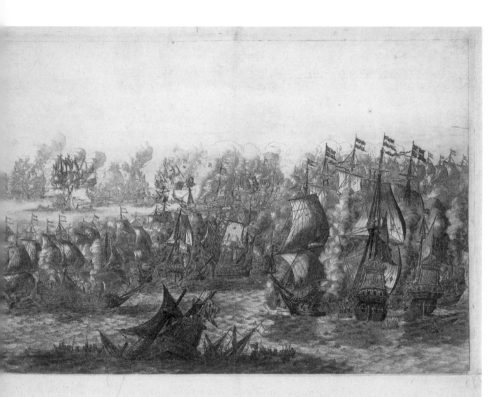

Afbeelding en kort verhaal / van den dapperen

Z E E · S L A G H,

Door de Scheeps-Vloot der Vereenigde Nederlanden, onder 't gezagh van den *Ed. Heer C. de Witt*, *Ruart van Putten*, en 't gebiedt van den Manhaften L. Admiraal *M. A. de Ruyter*, tegen die van de Franse en Engelse Scheeps-Vlooten, moedigijk bevochten, en victorieuselijk verkregen, op den 7 *Junii*, 1672.

Verklaring van de *Scheeps-Strijdt.*

1. De Onder-Admiral *van Gent*, slaande tegen 8 Engelsche Schepen.
2. Engelsche Schepen.
3. Een capitaal Frans Schip gezonken.
4. Den Schout by Nacht, *van Nes*, gaande over op 't Schip van Capiteyn *Lancourt*.
5. 't Schip van den Admiral *de Ruyter*.
6. 't Schip van den Hertog *van Torch*.
7. 't Schip van Capiteyn *Brakel*.
8. 't Schip van d'Engelsen Admiral *Montague*.
9. Een Engels Schip van 70 stukken verbrant.
10. 't Schip van *Cornelis Evertszn.*
11. 't Schip van *Josua* gaat te gronde.
12. Een Nederlands Schip, schietende
13. een Engels Schip in brandt.
14. 15, 16, 17, 18, 19 Het *Zeeuwse* Esquadre, slaande tegen de Franse Schepen.
20, 21, 22 Franse Schepen, die afdeynsen.
23 Een Engels Schip, te gronde gaande.
24 Een Brander wordt in brandt geschooten.
25, 26, 27, 28, 29 Franse Schepen buyten 't gevecht.

t'AMSTERDAM, By *Marcus Doornik*, op de Middeldam, 1672.

Tapestries with gold, silver thread and silk

It was probably around 1673-1674 that Willem van de Velde the Elder was commissioned to design a series of tapestries. A key indicator for this timeline is a letter written by the Dutch cartographer and director Pieter Blaeu (1637-1706) of Amsterdam to a close acquaintance of his, the Tuscan collector Cosimo de' Medici (1642-1723), who was always looking to buy drawings by Willem van de Velde the Elder. Blaeu was surprised when he had met Willem van de Velde the Elder on the streets of Amsterdam in 1674, thinking he was in England. Van de Velde boasted that he was in Amsterdam for a brief visit and would shortly be leaving again. He also confided that 'the King of England had done him the courtesy of awarding him a salary of 100 pounds sterling a year.' A commission to paint various large pictures followed immediately 'and based on those commissioned works a series of tapestries would be made with gold, silver thread and silk.'[33]

Van de Velde has initially been commissioned to design ten tapestries. Five to show the Battle of Lowestoft of 1660 and five to show the Battle of Solebay of 1672. The selected battles reveal the identity of Van de Velde's patron. It was not the king, but the Duke of York. The king's brother and heir to the throne who was appointed High Admiral of the Royal Navy in 1660. The Battle of Lowestoft was one of his first naval engagements as commander of the English fleet and Solebay would be his last. A year later, in 1673, James handed over command, the same year in which he likely commissioned Van de Velde to design the tapestries. In the end, the Lowestoft designs were never woven but instead of five, the Solebay series consisted of six tapestries.

While the tapestry designs may mark the beginning and end of James's maritime career, it remains puzzling why he chose to celebrate such an indecisive battle. An English verse offers a clue:

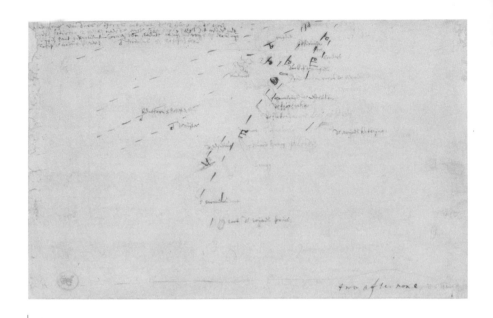

A
Willem van de Velde the Elder (1611-1693), Sketch of the situation at the Battle of Solebay with comments by James, c. 1672-1685. Collection Museum Boijmans Van Beuningen Rotterdam.
MB 1866/T 90

The notes Van de Velde added after discussing the sketch with James, Duke of York, are visible. Below left is the galliot in which Van de Velde was sailing.

'They battered without let or stay,
Until the evening of the day,
The Duke [of York] had beat them tightly.

Of all the battles gained at sea
This was the rarest victory
Since Philip's grand Armada'[34]

The Battle of Solebay was portrayed in the English court as an English triumph and a fitting response to the humiliating end of the previous war against the Dutch. For the English king, the supposed victory at Solebay was apparently suitable revenge.

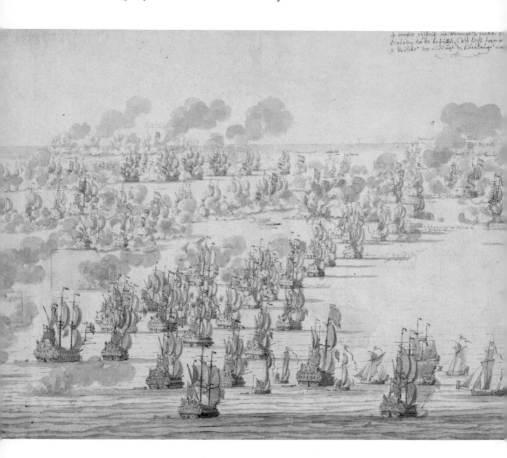

In the same letter which Johan de Witt wrote to diplomat Coenraad van Beuningen, De Witt referred to an extraordinary rumour. Charles II was especially irritated by the way people in the Dutch Republic regarded the Second Anglo-Dutch War after it ended. One particular example was the rumour that a series of tapestries was being designed showing the Medway raid, and featured scenes highlighting the triumph of the Dutch and the disgrace of the English. De Witt made exhaustive inquiries among the dignitaries of Amsterdam and Rotterdam to find out whether there was any truth in the rumour, but no one had heard of plans for such tapestries.[35] No such tapestries are known to have been woven, yet the notion is hardly strange. The province of Zeeland had commissioned marine artist Hendrik Cornelisz Vroom (c. 1562/1563-1640) to design a series of

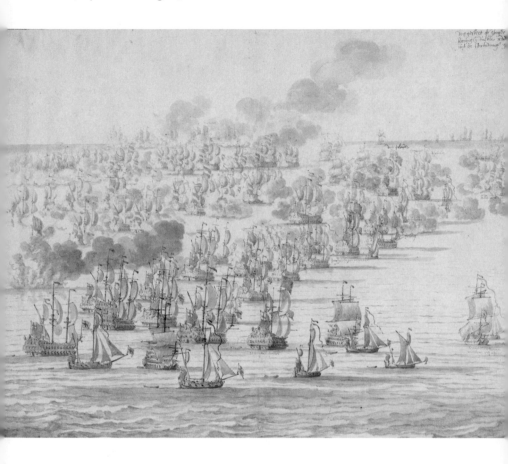

◄
Willem van de Velde the Elder
(1611-1693), Sketch of the Battle of
Solebay, c. 1673. Collection Leiden
University Libraries.
PK-T-2017

▲
Willem van de Velde the Elder
(1611-1693), Sketch of the Battle of
Solebay, c. 1673. Collection Leiden
University Libraries.
PK-T-2018

These two drawings of the Battle
of Solebay were probably made in
preparation for the tapestry designs.

tapestries showing naval victories of the Dutch Revolt, for instance. Those six tapestries depicted some of the high points of Zeeland's maritime history. Whether or not they existed, the idea that a series of Medway tapestries were made in the Netherlands became a topic of court gossip.

This was not the first time Willem van de Velde the Elder was asked to design a series of tapestries. In the 1650s, he created a series of tapestry designs for a leading Swedish general, Carl Gustaf Wrangel (1613-1676). Van de Velde the Elder discussed themes for various paintings with Wrangel by letter and in his book *Van de Velde & Son* Remmelt Daalder cites passages which indicate designs Van de Velde may have made for these Swedish works. Unfortunately, their correspondence did not lead to an agreement and Van de Velde's designs were apparently never woven.[36]

Although Van de Velde the Elder had some experience with design-ing tapestries, he did have one problem when it came to creating the Solebay designs. He had been present at the Battle of Solebay shortly before leaving for England in the winter of 1672/1673 when the Admiralty of Amsterdam commissioned him once again to make an illustration of the battle. His sketches therefore showed the events from a Dutch perspective. When it came to the English and French view of what happened, Van de Velde knew relatively little. In England, he found the Duke of York the ideal person to fill that gap. After all, James had commanded the Anglo-French fleet during the Battle of Solebay and would be able to complete the picture with his own observations. Several examples of James's modifications have been preserved. Now, having the additional information he needed, Willem van de Velde the Elder was ready to design the tap-estries.[37]

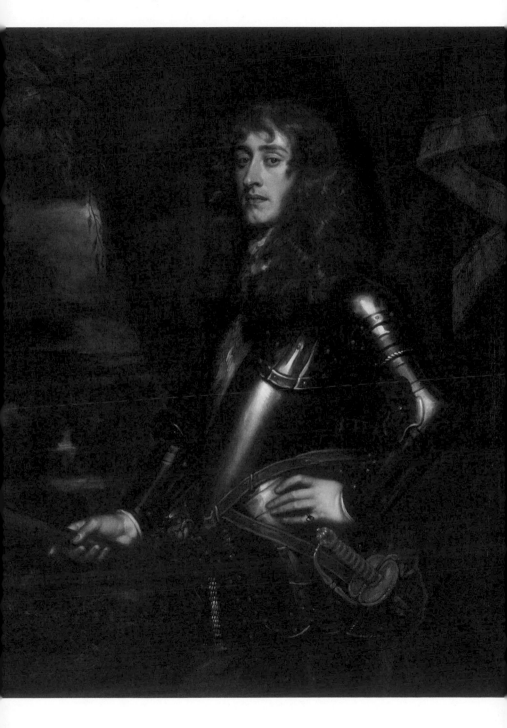

Alongside the drawings Van de Velde made during the Battle of Sole-
bay, several preparatory sketches for the tapestry designs have also
survived. These sketches differ in terms of perspective. While the
real-time sketches have a low vantage point, placing the observer –
like Van de Velde – in the middle of the battle, the tapestry designs
show the scene from a bird's-eye view.[38] This enabled Van de Velde
to show the course of events more clearly in the tapestries. These
sketches were not copied directly to the tapestries. So-called car-
toons were made of the sketches, and these were the designs used
by the weavers. The people working the looms, the English weavers
Francis and Thomas Poyntz, used these life-size cartoons as their
pattern.

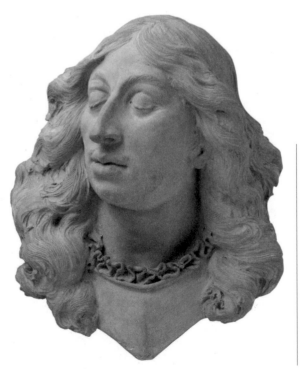

◀
Rombout Verhulst (1624-1698),
Portrait of Baron Willem Joseph
van Ghent (1626-1672), c. 1673.
Collection Rijksmuseum
Amsterdam. On loan from the
Royal Cabinet of Paintings,
Mauritshuis The Hague.
BK-NM-13151

Vice Admiral Willem van Ghent
died at the Battle of Solebay
when he was mortally struck by
canister shot tearing away his
lower leg and penetrating his
chest.

Mortlake Tapestry Works

Once Willem van de Velde the Elder completed the designs, they were woven initially by Francis Poyntz and later by Thomas Poyntz. It is generally assumed that the tapestries were woven at Mortlake Tapestry Works. The factory had been in operation since 1619, weaving wall hangings for English royal patrons in emulation of the French Gobelin works. Gobelin tapestries were highly prized in the seventeenth century and played a key role in the court culture of Europe's royal households—a culture from which the Stuart kings of England drew heavily as they cultivated their own court ethos. There had previously been no local tradition of tapestry making for the royal patrons in England. Significantly, the best-known royal tapestries in England, those celebrating the defeat of the Spanish Armada in 1588, were designed by Dutchman Hendrik Cornelisz Vroom (c. 1562/1563-1640) and woven by a weaver from the Dutch town of Delft.[39] Vroom also designed the Zeeland tapestries showing episodes from the Dutch Revolt, woven between 1593 and 1604. The sixth in that series was based on a design by Karel van Mander and all are now on display at the Zeeuws Museum in Middelburg.

While it is uncertain whether or not the Solebay tapestries were actually woven at Mortlake Tapestry Works, work on the first set certainly began around 1673. Three tapestries were woven then, titled *The Dutch fleet appears at dawn, The English fleet attacked by the Dutch* and a smaller filler-piece called an *entrefenêtre*.[40] Francis Poyntz is referred to in 1678 as 'the King's tapestry-maker' and so he may have been by then in the direct employ of the royal court rather than the Mortlake factory. As a royal weaver, Poyntz received an annual salary from the Crown and in addition he also sold occasional tapestries to the king. In an undated memorandum, Francis Poyntz applied for more funds to be able to continue his work on 'a suite of seafights.'[41] The sum Francis Poyntz asked probably did not arrive as for a while, the first set remained unfinished. Work did not resume until after Francis Poyntz's death in 1685. Three other tapestries were also woven around that time: *Fleets drawn up in lines of battle* and two views showing the burning of the *Royal James*. The first three tapestries are signed by Francis Poyntz; the later tapestries by Thomas Poyntz. A memorandum of 1688 refers

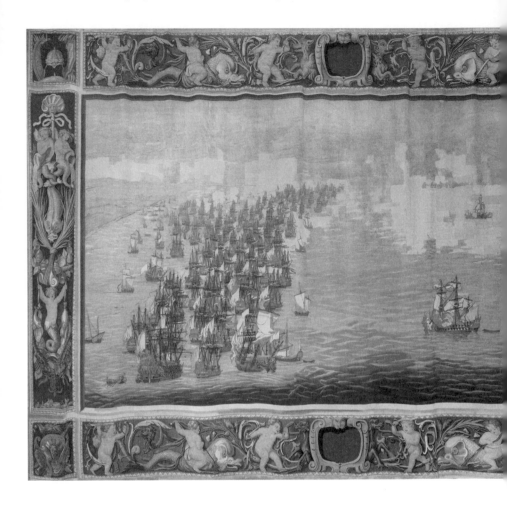

to 'three pieces of tapestry hangings of the story of the sea fight at Swowlebay [sic]', 'his majesty hath formerly bought and paid for, and these three pieces are to compleate the shute.' It therefore seems probable that Thomas Poyntz continued working on the project around 1688.[42]

The year 1688 is better remembered for a major historic event. After the death of king Charles II in 1685, his brother James became king. Both Charles and James were Catholics. Although Charles only acknowledged it on his deathbed, for James religion came first, and he made no secret about it. Tensions rose in England as James

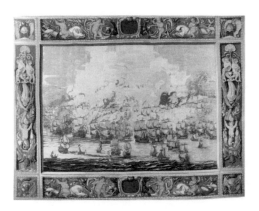

∧
Francis Poyntz (d. 1685) after Willem van de
Velde the Elder (1611-1693), The English fleet
attacked by the Dutch. Royal Collection Trust /
© His Majesty King Charles III 2023.
RCIN 1145.

◀
Francis Poyntz (d. 1685) after Willem van de
Velde the Elder (1611-1693), The Dutch fleet
appears at dawn. Royal Collection Trust /
© His Majesty King Charles III 2023.
RCIN 1145.

The English fleet is lying at anchor at Solebay.
The Dutch fleet appears on the horizon. Three
English scouts raise the alarm.

attempted to steer the country in a new direction until eventually,
a group of leading Protestant Englishmen appealed to the Dutch
stadholder prince Willem III of Orange (1650-1702). The Dutch prince
was to cross the North Sea and take the English crown in order
to prevent it from falling into Catholic hands and England would
become a Catholic country. This coup d'etat became known as the
Glorious Revolution of 1688. William and Mary (1662-1694) became
king and queen of England, Scotland and Ireland. This was not only
political, but very personal for all involved, as Mary was the daughter
of James II.

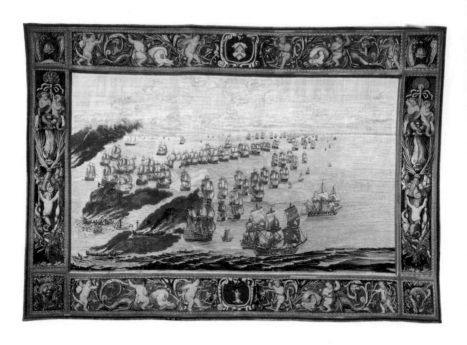

Michael Robinson showed that a royal inventory drawn up in 1695, following the death of Queen Mary, mentions only three tapestries featuring naval engagements. These were presumably the three hangings woven by Francis Poyntz, which are still part of the Royal Collection.[43] By the time the three additional tapestries were completed in the late 1680s, the defeated James II had fled to France in exile. That first set was therefore never shown together.

Presumably, the three tapestries later woven by Thomas Poyntz were acquired privately. By the 1720s, they were in the possession of the prominent Walpole family. That explains why the three later tapestries show the Walpole family crest in the cartouche at the top. Apart from the crest, the style and the decorative border correspond with the first three hangings. The three later Walpole tapestries were put up for sale in 1968 and were acquired for the British nation.[44] Two tapestries are now part of the Royal Historic Palaces collection[45] and the third is at the National Maritime Museum in Greenwich.[46]

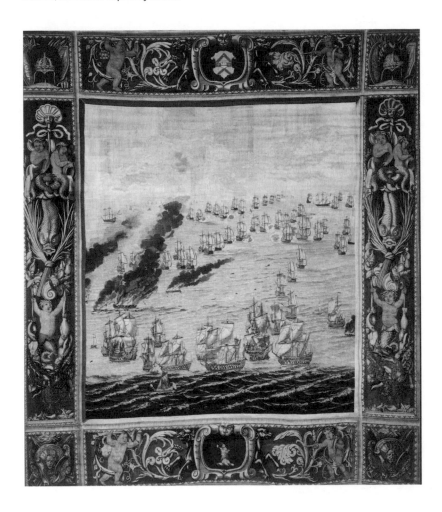

◀
Thomas Poyntz (?-?) after Willem van de Velde the Elder (1611-1693), The burning of the *Royal James*. Collection National Maritime Museum Greenwich.
TXT0106

▲
Thomas Poyntz (?-?) after Willem van de Velde the Elder (1611-1693), The burning of the *Royal James* later in the day. © Historic Royal Palaces.
3003477

The burning of the *Royal James* appears twice in the tapestry series. Part of this tapestry was apparently cut at a later date.

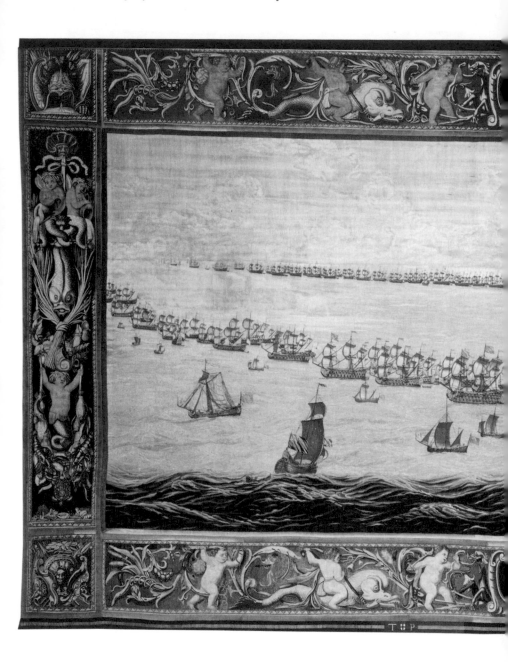

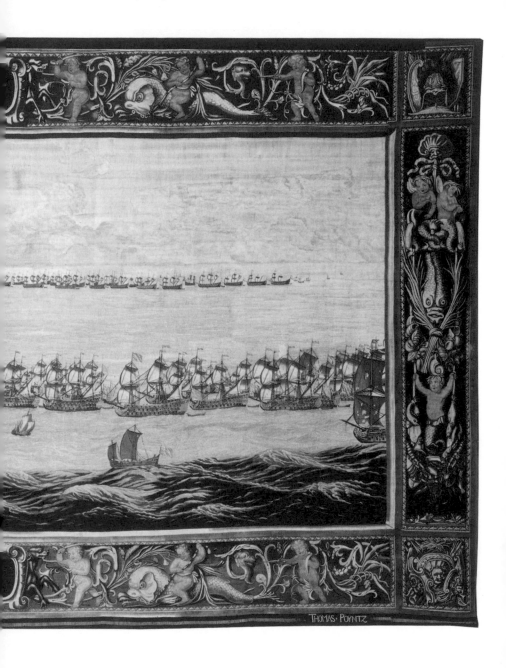

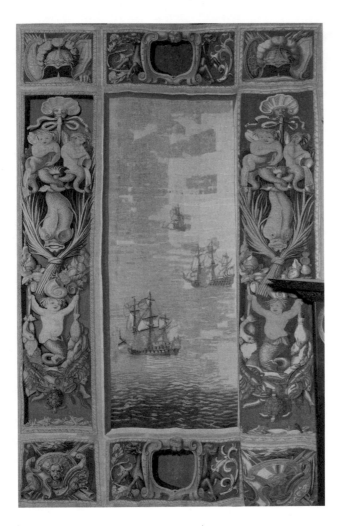

◄
Thomas Poyntz (?-?) after
Willem van de Velde the Elder
(1611-1693), Fleets drawn up in
line of battle. © Historic Royal
Palaces.
3003476

▲
Francis Poyntz (d. 1685) after Willem van de
Velde the Elder (1611-1693), Entrefenêtre,
Royal Collection Trust /© His Majesty King
Charles III 2023.
RCIN 1145

This tapestry was intended for a space
between two windows or doors, it literally
means 'between windows' in French.
The scene corresponds with part of
'The Dutch fleet appears at dawn'.

The Dartmouth set

The tapestries at the Scheepvaartmuseum in Amsterdam are part of a later set. This second set was woven for George Legge (1647-1691), first baron of Dartmouth, an admiral under Charles II and James II. Legge rose through the ranks rapidly first serving as a volunteer during the Four Days' Battle and one year later was made captain of HMS *Pembroke*, a 28-gun warship. Within one month, however, he lost his ship following a collision. Early in 1672 he was given command of HMS *Fairfax,* which was part of the squadron that attacked the Smyrna convoy at the start of the Third Anglo-Dutch War. It was in *Fairfax* that Legge would later sail at the Battle of Solebay.[47]

On land, Legge collected a series of appointments. In 1672, he was named Lieutenant General of the ordnance; in 1673, Master of the Horse to the Duke of York; in February 1673, he entered Parliament and in 1678, he was named Artillery General of the English army in Flanders, although no fighting took place there. In 1682, he was made Baron of Dartmouth. His most spectacular achievement, how-ever, was in May 1682. Legge was on board HMS *Gloucester* with the Duke of York when the ship struck a sandbank. In the ensuing panic, Legge apparently held off the crowd with his sabre to enable James to escape in one of the jolly boats. In 1683, he was given command of a naval expedition to Algiers. In fact, maritime historian J.D. Davies considers Legge to have been the nearest James had to a friend, one of his few close contacts.[48]

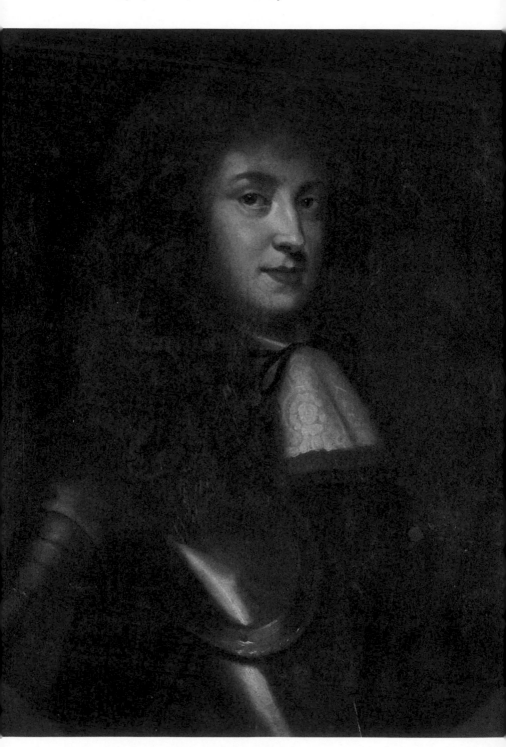

The later Dartmouth tapestry set was intended as a gift. At the top, the decorative border features two drums with a drum cloth bearing the initials J and R: *James Rex*. The cartouche – which had remained empty in the first tapestries and made way for the Walpole crest on the later hangings of the first set – is richly decorated with George Legge's heraldic arms. Although Dartmouth admitted that he lacked a naval education, he had little experience as a naval commander and he lost a ship he captained, in 1688 he was made Admiral of the Fleet. His most important mission was to stop the Dutch fleet, carrying William and Mary, advancing from the Netherlands. An impossible task, not least because of the divided loyalties of his subordinates. Once William and Mary set foot on land there was no stopping their Glorious Revolution. For Legge, his career ended with the flight of his royal patron. Although he later swore allegiance to the new king and queen, he was arrested in 1691 for high treason. His reputation as a loyal adherent of the old Stuart regime proved his undoing. Legge was imprisoned in the Tower of London and died there the following year.[49]

It seems that the set which was woven specially for Dartmouth never reached him. The new English sovereigns William and Mary tried to break with their predecessors' traditions to chart their own reign on a different course, one with a more emphatic direction. The tapestries were old relics, representing the deposed Catholic king.

◄

Anonymous, Portrait of George
Legge, first baron of Dartmouth
in armour, second half of the
seventeenth century. Collection
National Maritime Museum
Greenwich.
BHC2644

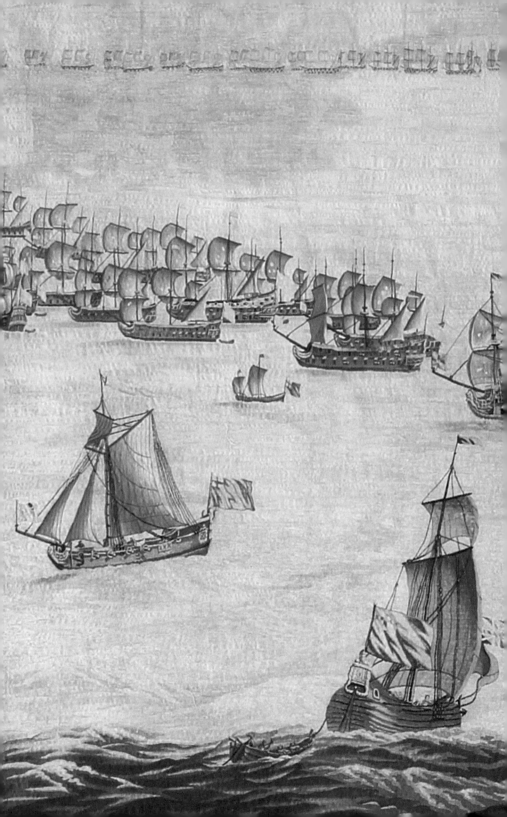

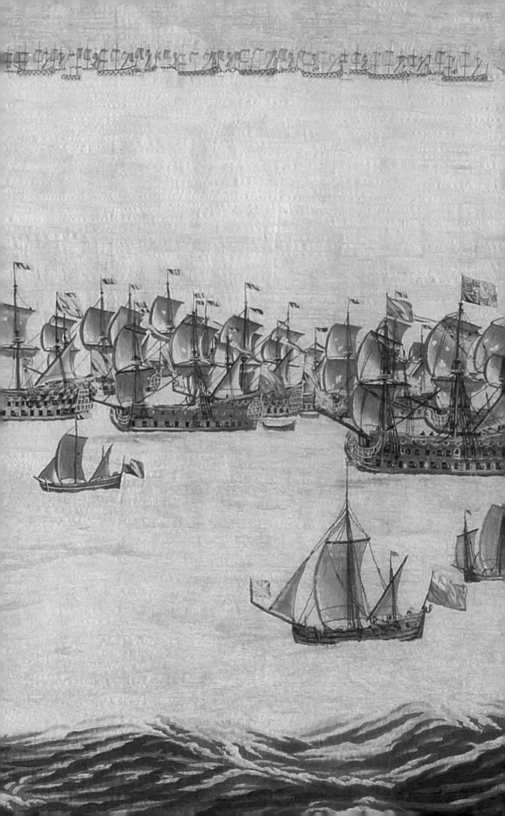

'We were unable to engage or approach the enemy[...], and apparently [they] lacked any interest in attacking us which they could have done quite easily throughout the day.'[53]

◄
The fleets drawn up in line
of battle, c. 1685. (detail)
See page 84

What do the tapestries show?

The tapestry series portrays key moments in the Battle of Solebay. It tells a graphic narrative. The story begins in the first scene with the initial confrontation: the Anglo-French fleet is lying at anchor at Solebay, while the Dutch fleet appears on the horizon. The next tapestry shows the ferocious contest already underway. Then, no less than two tapestries depict the *Royal James* ablaze. The series ends with a scene in which the ships are drawn up in lines of battle. In addition, one narrow tapestry, an *entrefenêtre*, was made to hang between two windows or doors.

Two of each tapestry seem to have been woven. One for the royal set and one for the Dartmouth set. The tapestry compositions of both sets are practically identical, only the borders differ. Whereas the first set has a standard design combining various classical elements, the border of the Dartmouth set features elements that specifically refer to the maritime theme of the tapestries. Several flags are depicted, for example, as well as weapons and nautical instruments. Given the major differences, it seems unlikely that Van de Velde the Elder designed either of these borders.

Another interesting difference involves the two *entrefenêtres*. In the first set, it seems to echo a scene from *The Dutch fleet appears at dawn,* showing the scouts returning to raise the alarm having spotted the approaching Dutch fleet. The other *entrefenêtre* shows ships from the red squadron engaged in combat, reminiscent of the second tapestry in the series. Finally, all the tapestries in the Dartmouth set are slightly smaller than those which were woven for the king.

The fleets drawn up for battle

It would be natural to assume that the biggest tapestry represents the start of the Battle of Solebay. In the foreground, arranged from left to right are the white, red and blue squadrons of the English fleet. Smaller ships sail back and forth in the foreground, possibly involved in the battle as support vessels, for example delivering messages. Looming on the horizon, barely visible, are the Dutch ships. It looks as if the ships are preparing to fight in line ahead. However, several ships in the English red squadron seem to be flying torn flags and have holes in their sails while various Dutch ships on the horizon appear to be sailing under makeshift canvas while the English blue squadron, flying the blue flag from the main mast, seems to have lost its flagship. Perhaps, it would be more logical to see this not as the start of the battle, but the end, by which time the Vice Admiral of the blue squadron, Lord Sandwich, was already dead. In the line of battle the Royal James is indeed missing.

In his log, Edward Spragge, Vice Admiral of the red squadron, described the council of war held on the morning of 8 June on board the *Prince* stating, 'The result was that, in consideration of the scarcity of ammunition and several of our ships being disabled in their masts and sails, we should go into the river and fit; this being no sooner resolved than the enemy appeared standing with us.'[50] John Narbrough (captain of the *Prince*) wrote in his log, 'just as we were ready to fire [...] a mighty thick fog came over from the North East, that we could not see the next ship to us.' When the fog lifted a few hours later, the Duke of York seized the opportunity. The English fleet had managed to maintain its formation in the haze: 'His Royal Highness commanded the flag of defiance to be hoisted [...] and the ship's company gave three shouts for joy, to see it flying so near the enemy.'[51] Yet the fighting had stopped. For Spragge, the reason was clear: 'The French were very slack in bearing down and in great dis-order; nor I do expect better from them [...] Three times the French have been slack in bearing down to the enemy, which had they done, we should have entire victory.'[52] On the second morning, the fleets disperesed without a single shot fired.

In August, when the De Witt brothers were both imprisoned in The Hague, the general accusations of treason against them were largely based on a rumour that Cornelis had prevented a resumption of hostilities on that second day of the Battle of Solebay. On 4 August, Michiel de Ruyter wrote to the States General to assure the accusers that Cornelis had done all he could to resume the battle that day, but that 'we were unable to engage or approach the enemy[...], and apparently [they] lacked any interest in attacking us which they could have done quite easily throughout the day.'[53]

The tapestry clearly shows the royal standard of the Duke of York on the main mast of one of the ships in the centre of the red squadron. Another interesting detail is the sight of church pennants on various masts in the foreground. These would normally be flown to indicate a religious service being held on board and these pennants are a combination of the Dutch tricolour and the English cross of St George. Perhaps the casualties of the day before were being remembered.

> ➤
> Thomas Poyntz (?-?) after
> Willem van de Velde the Elder
> (1611-1693), The fleets drawn
> up for battle, c. 1685.
> 2020.0001

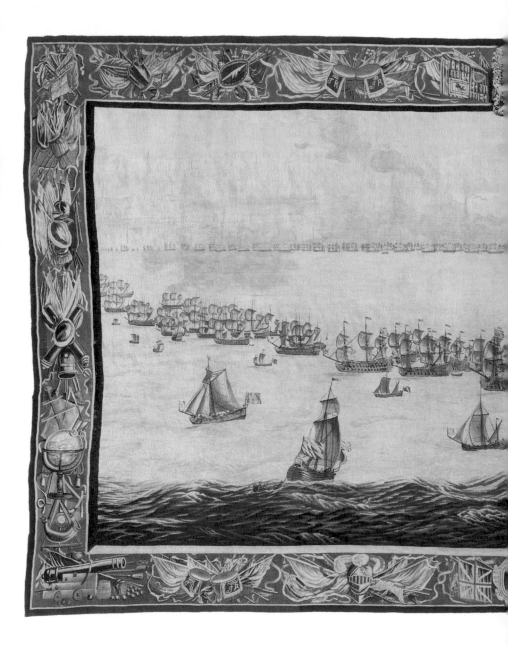

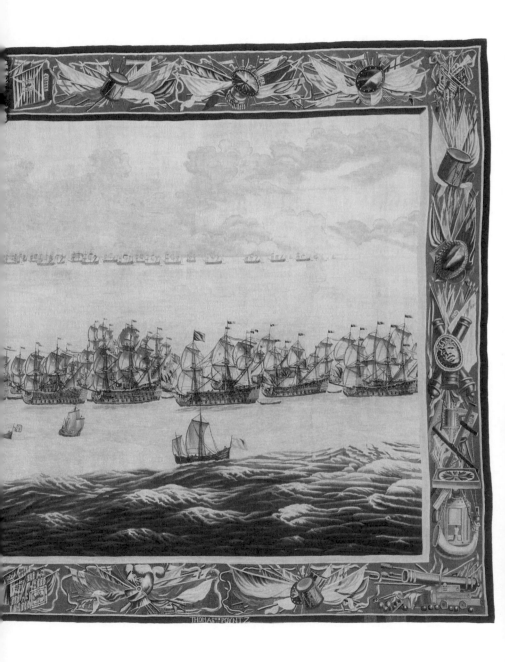

Another intriguing aspect of *The fleets drawn up for battle* is that the wind seems to be blowing from two directions. For the English ships arranged in line of battle, the wind seems to be coming from behind, while the direction of the pennants and flags suggests that the ships are sailing against the wind. Since Van de Velde the Elder was known for his accuracy, it raises an interesting question regarding the authorship of the design. Whose work is it that we see here? Unfortunately, the answer remains purely speculative since none of the cartoons used by the weavers have survived. We can no longer check which direction the pennants and flags flew in the original design. They fly in the same direction in the tapestry from the first set, that much is clear. Did James change their direction to ensure that his royal flag was visible? Did Thomas Poyntz improve the designs with his own embellishments?

The burning of the *Royal James*

The other tapestry in the Scheepvaartmuseum collection shows the decisive moment in the Battle of Solebay: the successful attack by a Dutch fireship on the *Royal James*. The captain of this vessel was Vice Admiral of the Blue Edward Montagu, the first Earl of Sandwich (1625-1672). His ship was a major target for the Dutch from the start. Vice Admiral Willem Joseph van Ghent (1626-1672) led his squadron in an attack on Sandwich's blue squadron. Amid the fierce exchange of fire, Van Ghent was killed. Several fireships then attempted to set the *Royal James* alight. Eventually, Captain Jan Danielsz van Rijn managed to steer his fireship *Vrede* up to the English flagship and the flames spread. Sandwich himself was among the dead.[54] It seems that he refused to abandon his burning ship. His body washed ashore sometime after and was only identified by the emblems on his remaining clothing.[55]

To the left on the tapestry, the *Royal James* is shown while it burns. The blue squadron's flag is clearly visible despite the smoke. The ship is surrounded by several smaller vessels, all aflame. These may be what remained of the first fireships. Various ships of the red squadron are shown in the foreground. These were probably trying to join the remainder of their squadron which is sailing towards the horizon in the centre of the tapestry. Clearly recognisable in middle of the tapestry is the royal standard of the Duke of York. He is engaging a line of Dutch ships, under attack from the other side by ships from the blue squadron. Incidentally, this tapestry provides a far clearer picture of the prevailing direction of the wind that day.

➤
Thomas Poyntz (?-?) after Willem van de Velde the Elder (1611-1693), The burning of the *Royal James* later in the day, *c*. 1685.
2020.0002

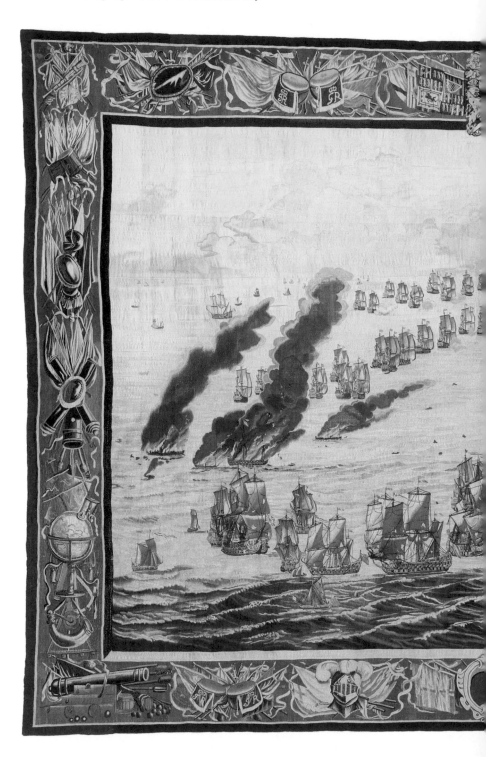

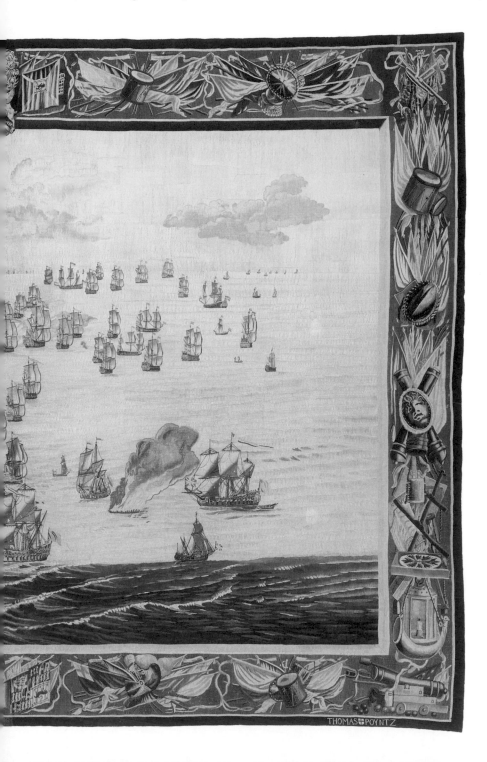

THOMAS POYNTZ

Conclusion

The Solebay Tapestries are a major acquisition for the Scheepvaart-museum. They depict a key moment in Dutch history, the Battle of Solebay and the disaster year of 1672, from a unique perspective. This English view of the battle sheds a new light on one of the seminal moments in the maritime past of both countries. A moment, the Battle of Solebay, which was already well represented from the Dutch vantage point, is now given added meaning thanks to this purchase.

At the same time, there is something quintessentially Dutch about these tapestries. They are part of a tradition that goes back to the English Armada tapestries and the Zeeland tapestries of the Dutch Revolt, designed by Hendrick Cornelisz Vroom. The Solebay Tapestries were designed by one of the Netherlands' greatest marine artists, Willem van de Velde the Elder. At the Scheepvaart-museum, the oeuvre of both Van de Veldes, father and son, has always been held in high regard and works by these artists were among the first purchased by the museum's founders. With the acquisition of the Solebay Tapestries, the Scheepvaartmuseum can now show a key link in the Van de Velde family workshop, demonstrating the breadth of their oeuvre. It also serves as a record of their royal patronage when they worked for the kings of England in their workshop in Greenwich.

Some questions remain unanswered. What was the connection between the weavers Francis and Thomas Poyntz and the Royal Tapestry Works at Mortlake? Who was the real author of the tapestries? Where did Van de Velde's design end and where did the weavers' interpretation take over? How should we view the tapestries in the context of the new wave of English art inspired by the new sovereigns, William and Mary?

Hopefully, answers to these questions will emerge at some point. But even without those answers, the tapestries represent an important link in Willem van de Velde the Elder's oeuvre and they remain a magnificent portrayal of a crucial confrontation in Dutch and English history.

Notes

1 'Sir John Harman's account', in: R.C. Anderson (ed.), *Journals and narratives of the Third Dutch war* (London 1946) 172-173, esp. 173.
2 'Journal of Sir Edward Spragge, Vice Admiral of the Red and Admiral of the Blue', in: R.C. Anderson (ed.), *Journals and narratives of the Third Dutch war* (London 1946) 155-163, esp. 156.
3 The Dutch date for the Battle of Solebay is 7 June 1672, following the Gregorian calendar, to which most Dutch provinces had converted in 1582. For the English, who didn't switch from the old-style Julian calendar until 1752, the date was 26 May 1672. Here, all dates are according to the Gregorian calendar. To get the date found in British sources and commonly used by British historians, subtract ten days.
4 Ronald B. Prud'homme van Reine, *Opkomst en ondergang van Nederlands gouden vloot: Door de ogen van de zeeschilders Willem van de Velde de Oude en de Jonge* (Amsterdam 2009) 196-198.
5 Johannes de Jonge, *Geschiedenis van het Nederlandsche Zeewezen. Tweede deel, eerste stuk* (Haarlem 1859) 303-305; Graddy Boven, 'Op de rand van de afgrond: de zeeslag bij Solebay op 7 juni 1672', in: *Arma: Jaarboek Stichting Koninklijke Defensiemusea* (Zutphen 2022) 24-53, esp. 51.
6 Jonathan I. Israel, *The Dutch Republic: Its rise, greatness and fall, 1477-1806* (Oxford 1998) 713-714, quoted on 714; Roger Hainsworth and Christine Churches, *The Anglo-Dutch naval wars, 1652-1674* (Stroud 1998) 14-15.
7 Hainsworth and Churches, *The Anglo-Dutch naval wars* 15-18.
8 J.R. Jones, *The Anglo-Dutch wars of the seventeenth century* (London 1996) 115-133; Jaap R. Bruijn, *Varend verleden: de Nederlandse oorlogsvloot in de zeventiende en achttiende eeuw* (Amsterdam 1998) 91-92; Peter Sigmond and Wouter Kloek, *Zeeslagen en zeehelden in de Gouden Eeuw* (Amsterdam 2007) 73-81; Luc Panhuysen, *Het monsterschip: Maarten Tromp en de armada van 1639* (Amsterdam 2021)

153-154, 233-236.
9 Israel, *The Dutch Republic* 721-722; Jones *The Anglo-Dutch wars* 141-142.
10 J.R. Bruijn, *Varend verleden* 95-97.
11 Israel, *The Dutch Republic* 765-768; Jones *The Anglo-Dutch wars* 150-151; J.R. Bruijn, *Varend verleden* 101-103.
12 Israel, *The Dutch Republic* 768-773; Jones *The Anglo-Dutch wars* 158-177; Luc Panhuysen, *De ware vrijheid: de levens van Johan en Cornelis de Witt* (Amsterdam 2005) 331-332.
13 Panhuysen, *De ware vrijheid* 337-340; Letter from Johan de Witt to Cornelis de Witt on 27 June 1667, in: R. Fruin and G.W. Kernkamp (ed.), *Brieven van Johan de Witt, 1650 – 1672. Deel III* (Amsterdam 1906) 306.
14 J.D. Davies, *Kings of the Sea: Charles II, James II and the Royal Navy* (Barnsley 2017) 40-41.
15 Letter from Johan de Witt to Koenraad van Beuningen, 21 November 1672. In: Robert Fruin, *Brieven van Johan de Witt, vierde deel: 1670-1672* (1913 Amsterdam) 106-111, esp. 108.
16 P.G. Rogers, *The Dutch in the Medway* (London 1970) 126-127; Marjan Scharloo, 'Majesteitsschennis in metaal?' in: Jan Pelsdonk and Michiel Plomp (ed.), *Hulde! Penningkunst in de Gouden Eeuw* (Haarlem 2012) 25-39.
17 Letter from Johan de Witt to Koenraad van Beuningen on 21 November 1672 108; Rogers, *The Dutch in the Medway* 129-130; Davies, *Kings of the Sea* 202-204.
18 Scharloo, 'Majesteitsschennis in metaal?' 37; Anne Doedens, Liek Mulder and Frits de Ruyter de Wildt, *Agenten voor de koning: Engelse Spionage tijdens het Rampjaar, 1672-1673* (Zwolle 2022) 50.
19 Jones, *The Anglo-Dutch wars* 175-176; P.G. Rogers, *The Dutch in the Medway* 129; Panhuysen, *De ware vrijheid* 377.
20 Remmelt Daalder, 'De firma Van de Velde: Maritieme kunst in Amsterdam en London', in Jeroen van der Vliet, *Willem van de Velde & Zoon* (Amsterdam 2021) 8-19, esp. 10.
21 Koos de Wilt, 'De wereld achter de wolken. Schilderijenrestaurator, schilderdocent en kunsthistoricus Caroline van der Elst over de restauratie van de Episode uit de zeeslag in de Sont van Willem van de Velde de Oude (1611-1693)' in *Zeemagazijn Oktober* (2021) 12-16; Remmelt Daalder,

94

Van de Velde & Zoon, zeeschilders: het bedrijf van Willem van de Velde de Oude en Willem van de Velde de Jonge, 1640-1707 (Amsterdam 2016) 109-110.

[22] Jeroen van der Vliet, 'Naar zee met de Van de Veldes', in Jeroen van der Vliet, Willem van de Velde & Zoon (Amsterdam 2021) 20-31, esp. 22-27.

[23] Daalder, Van de Velde & Zoon, zeeschilders 129-132.

[24] Ibid 145-149.

[25] Luc Panhuysen De ware vrijheid 402-403.

[26] Pamflet: Monsieur ende vrient. Ick twyffele niet ofte U.E. sal mynen voorgaenden van den 2. deser ter handt gekomen zyn... (s.l. 1672) Knuttel catalogue 10132.

[27] Luc Panhuysen De ware vrijheid 405.

[28] 'Journaal gehouden op het schip De Zeven Provinciën door Michiel de Ruyter, luitenant-admiraal onder de Admiraliteit op de Maze, als chef van de vloot uitgezonden om te ageeren tegen de gecombineerde Engelsche en Fransche zeemacht', National Archive: 1.10.72, 19. Folio 21. Transcription provided by the University of Utrecht's Language Dynamics in the Dutch Golden Age project.

[29] Cornelis de Witt to Johan de Witt on 8 June 1672, in: R. Fruin and N. Japikse, Brieven aan Johan de Witt: Tweede Deel (Amsterdam 1922) 681.

[30] Ibid.

[31] Anne Doedens and Matthieu J.M. Borsboom, De canon van de Koninklijke Marine: geschiedenis van de zeemacht (Zutphen 2020) 74-75.

[32] Menzo Willems, 'Guerrilla op de Waterlinie': mariniers op platbodems vochten op binnenwateren tegen de Fransen', De Telegraaf (21 February 2023) D9.

[33] Daalder, Van de Velde & Zoon, zeeschilders 142-146.

[34] M. Jourdain 'Lord Iveagh's Solebay Tapestries', Country Life (1929) 351-353, quoted on 351.

[35] Letter from Johan de Witt to Koenraad van Beuningen 108-109.

[36] Daalder, Van de Velde & Zoon, zeeschilders 112-113.

[37] Ibid 151-156.

[38] Ibid 152-156.

[39] Simon Turner, 'Van Dyck and Tapestry in England', in Tate Papers 17 (2012) https://

www.tate.org.uk/research/tate-papers/17/van-dyck-and-tapestry-in-england, last accessed 26 February 2021.

[40] Now part of the Royal Collections Trust collection, inventory no. RCIN 1145.

[41] Robinson, 'Mortlake tapestry of the Battle of Solebay', 1; Jourdain 'Lord Iveagh's Solebay Tapestries' 352.

[42] Robinson, 'Mortlake tapestry of the Battle of Solebay', 2.

[43] Ibid.

[44] Christie's auction catalogue: Catalogue of the contents of Pyrford Court, Woking, Surrey (1968) 50.

[45] Fleets Drawn up in Lines of Battle, inventory no. 3003476; Fireships in Action, inventory no. 3003477.

[46] The Burning of the Royal James at the Battle of Solebay, 28 May 1672, inventory no. TXT0106.

[47] J.D. Davies, 'Legge, George, first Baron Dartmouth (c. 1647-1691), Oxford Dictionary of National Biography (published on 28 September 2006).

[48] Jourdain, 'Lord Iveagh's Solebay Tapestries', 353 and Davies, Kings of the Sea 224 and 232.

[49] 'George Legge, 1st Baron Dartmouth', Encyclopaedia Britannica via: www. britannica.com, last accessed 26 February 2023; Davies, Kings of the Sea 232-233.

[50] 'Journal of Sir Edward Spragge', 157.

[51] 'Journal of John Narbrough, Lieutenant and Captain of Prince', in: R.C. Anderson (ed.), Journals and narratives of the Third Dutch war (London 1946) 57-154, esp. 103-104.

[52] 'Journal of Sir Edward Spragge', 157.

[53] Pamflet: Michiel de Ruyter, Brief van Michiel de Ruyter aan de Staten van Holland ter rechtvaardiging van Cornelis de Witt, gedagtekend 4 augustus 1672 (s.l. 1672) Knuttel catalogue 10181.

[54] Sjoerd de Meer, 'Het verbranden van de 'Royal James' in de zeeslag bij Solebay, 7 juni 1672' in Humphrey Hazelhoff Roelfzema, Roeien met de riemen: 75 jaar Vereeniging Nederlandsch Historisch Scheepvaart Museum (Amsterdam 1991) 165-166.

[55] Richard Dunn, 'The Burning of the Royal James at the Battle of Solebay, 28 May 1672', in Robert Blyth (ed.), Treasures of Royal Museums Greenwich (London 2018) 46-47.

Literature

Anderson, R.C., (ed.), *Journals and narratives of the Third Dutch war* (London 1946)

Boven, G., 'Op de rand van de afgrond: de zeeslag bij Solebay op 7 juni 1672', in: *Arma: Jaarboek Stichting Koninklijke Defensiemusea* (Zutphen 2022)

Bruijn, J.R., *Varend verleden: de Nederlandse oorlogsvloot in de zeventiende en achttiende eeuw* (Amsterdam 1998)

Daalder, D., *Van de Velde & Zoon, zeeschilders: het bedrijf van Willem van de Velde de Oude en Willem van de Velde de Jonge, 1640-1707* (Amsterdam 2016)

Davies, J.D., 'Legge, George, first Baron Dartmouth (c. 1647-1691), *Oxford Dictionary of National Biography* (published on 28 September 2006).

Davies, J.D., *Kings of the Sea: Charles II, James II and the Royal Navy* (Barnsley 2017)

Doedens, A.L. Mulder and F. de Ruyter de Wildt, *Agenten voor de koning: Engelse Spionage tijdens het Rampjaar, 1672-1673* (Zwolle 2022)

Doedens, A. and M.J.M. Borsboom, *De canon van de Koninklijke Marine: geschiedenis van de zeemacht* (Zutphen 2020)

Dunn, R., 'The Burning of the Royal James at the Battle of Solebay, 28 May 1672', in Robert Blyth (ed.), Treasures of Royal Museums Greenwich (London 2018) 46-47

Hainsworth, R. and C. Churches, *The Anglo-Dutch naval wars, 1652-1674* (Stroud 1998)

Israel, J.I., *The Dutch Republic: Its rise, greatness and fall, 1477-1806* (Oxford 1998)

Jones, J.R., *The Anglo-Dutch wars of the seventeenth century* (London 1996)

Jonge, J. de, *Geschiedenis van het Nederlansche Zeewezen. Tweede deel, eerste stuk* (Haarlem 1859)

Jourdain, M., 'Lord Iveagh's Solebay Tapestries', *Country Life* (1929) 351-353

'George Legge, 1st Baron Dartmouth', *Encyclopaedia Britannica* via: www.britannica.com, last accessed 26 February 2023

Meer, S. de, 'Het verbanden van de 'Royal James' in zeeslag bij Solebay, 7 juni 1672' in Humphrey Hazelhoff Roelfzema,

Roeien met de riemen: 75 jaar Vereeniging Nederlandsch Historisch Scheepvaart Museum (Amsterdam 1991) 165-166

Panhuysen, L., *De ware vrijheid: de levens van Johan en Cornelis de Witt* (Amsterdam 2005)

Panhuysen, L., *Het monsterschip: Maarten Tromp en de armada van 1639* (Amsterdam 2021)

Prud'homme van Reine, R.B., *Opkomst en ondergang van Nederlands gouden vloot: Door de ogen van de zeeschilders Willem van de Velde de Oude en de Jonge* (Amsterdam 2009)

Rogers, P.G., *The Dutch in the Medway* (London 1970)

Scharloo, M., 'Majesteitsschennis in metaal?' in: Jan Pelsdonk and Michiel Plomp (ed.), *Hulde! Penningkunst in de Gouden Eeuw* (Haarlem 2012)

Sigmond, P. and W. Kloek, *Zeeslagen en zeehelden in de Gouden Eeuw* (Amsterdam 2007)

Turner, S., 'Van Dyck and Tapestry in England', in *Tate Papers* 17 (2012) https://www.tate.org.uk/research/tate-papers/17/van-dyck-and-tapestry-in-england

Vliet, J. van der, *Willem van de Velde & Zoon* (Amsterdam 2021)

Wilt, K. de, 'De wereld achter de wolken. Schilderijenrestaurator, schilderdocent en kunsthistoricus Caroline van der Elst over de restauratie van de Episode uit de zeeslag in de Sont van Willem van de Velde de Oude (1611-1693)' in *Zeemagazijn Oktober* (2021)

Colofon

Publisher
Waanders Publishers, Zwolle
Het Scheepvaartmuseum

Author
Tim Streefkerk

Series Editor
Jeroen van der Vliet

Translation
Sam Herman and Charlotte Jarvis

Photography
Bart Lahr, Het Scheepvaartmuseum

Design
studio frederik de wal

Lithography
Benno Slijkhuis, Wilco Art Books

Printer
Wilco Art Books, Amersfoort

© 2023 Waanders Publishers b.v., Zwolle
and Het Scheepvaartmuseum

www.waanders.nl
www.hetscheepvaartmuseum.nl

ISBN 9789462624849
NUR 688

Also published in Dutch:
ISBN 9789462624832

The Solebay Tapestries: Threads of history
is the first volume in a series of publications
about objects in the collection of Het
Scheepvaartmuseum, the national maritime
museum of the Netherlands.

About the author:
Tim Streefkerk (1990) is curator
of decorative arts at Het Scheepvaart-
museum in Amsterdam.

Illustration cover
Thomas Poyntz (?-?) after Willem
van de Velde the Elder (1611-1693),
The fleets drawn up for battle, c. 1685.
2020.0001

Thomas Poyntz (?-?) after Willem
van de Velde the Elder (1611-1693),
The burning of the *Royal James*, c. 1685.
2020.0002